THE PLAYBOOK

For my daughters Eliza and Avery

THE PLAYBOOK

ALEX S. MACLEAN

introductory text by
Susan Yelavich

with 81 color illustrations

Thames & Hudson

PLAYTIME
Susan Yelavich

In his classic 1967 film *Playtime*, Jacques Tati follows his protagonist Monsieur Hulot as he stumbles his way through modern Paris. This is a Paris whose signature monuments, like the Eiffel Tower and Arc de Triomphe, are only visible indirectly, seen in the reflection of the revolving glass doors of the city's shining new towers. Like Tati, aerial photographer Alex MacLean keeps his distance from his subjects so that we can see them from a different perspective; and like Tati, he imbues his seductively playful images with a quiet subversiveness.

Playbook is MacLean's paean to a dimension of contemporary life all too often discounted as trivial or inconsequential: children play; gamblers play; slackers play; athletes play. In a society that places a premium on work, these players conduct their games on the margins, where the stakes are either the immaterial satisfactions of sandbox status or the extravagant perks of celebrity stature.

MacLean's photographs tell a different story, however. They are both a celebration of play and a document of its absorption into the Protestant work ethic.

Today, instead of viewing play with suspicion, corporations build their profits on it and groom their managers in its improvisatory virtues: creativity, intuition, fast thinking, and fleet action. MacLean doesn't editorialize; again, like Tati, he is benignly silent on the matter. Rather, he trains his camera with affection and acuity on the remarkable levels of invention through which we rationalize playing.

Playbook, as its name suggests, is a series of coded options. In American football, the playbook contains a series of diagrams of passes, blocks, and throws that are practiced and drilled in anticipation of the other team's moves. Likewise, MacLean's playbook offers insight into the systems, the architectures, of play. In the random array of blankets in a park or umbrellas on a beach, MacLean reveals our predilection to create patterns. On ball fields and gridirons, he shows us how we impose them, and in stadiums, how we contain them. In the baroque twists and turns of waterslides, he lets us see the genius of controlled confusion, how these liquid labyrinths are designed to raise heart rates within safe limits. MacLean shows us the slender realities that support every roller coaster rider's leap of faith. Taking us above the scenery of the carnival, he exposes the webs of steel that undergird the thrill of riding on a ribbon.

Of course, half the fun of play is based on the illusion of insecurity, and in his images of theme parks the photographer slyly pokes at our larger nervousness. Super-sized soccer balls, guitar-shaped swimming pools, and gargantuan tennis rackets assure anxious vacationers of exactly where they are. They also literally brand our choice of leisure activity and keep it within the respectable confines of capitalism. But he leaves us with no question that these are highly intelligent spaces; they illustrate just how much play depends on boundaries, deceptions, and fakes.

A skilled player himself, MacLean is adept at employing his own feints and illusions—strategies necessary to test the wits of the viewer. At the same time his images mesmerize us with the sheer brilliance of their patterns and their color, they also pull us into their mazes. He engages us in an optical guessing game. What is really going on between the lines here? Are we looking at pinwheels or a boardwalk of canopied carousels? Are those snowflakes? No, wait, they're boats docked on offshore rings. Look again and the zigzag turns of a game board turn out to be the tracks of a go-cart ride. It is a commonplace among educators that pattern-recognition is a key index of a child's intelligence. MacLean understands it is a talent crucial to the serious play of adulthood.

As both an artist and a documentarian, MacLean has spent much of his professional career cataloguing and collecting the tracks of our collective footprints in the sand. Parking lots packed with cars, golf courses built on landfill, and a collapsed hot air balloon silently testify that play has its environmental costs. Snow-blown basketball courts and baseball diamonds blanketed white are gentle reminders that nature still has the power to call the shots or at least delay the game. The calligraphy of marks left by ice fishing and motorcycle racing are the only traces of winter sport to be found here. Apart from these sparse, mysterious scapes, this is a book of perpetual summers.

MacLean is an American optimist. His vision is shaped by the ethos of a country whose Declaration of Independence guaranteed all of its citizens the inalienable right to the "pursuit of happiness." On the pages of his playbook, surfers, sailors, dirt bikers, and sun-seekers share the stage with marching bands and soldiers performing stage-ground maneuvers. MacLean doesn't reject the artificiality of these playing fields; he understands they are quite literally vital. Play is not the sole prerogative of children. From the cockpit of his plane, we are all small again. The leitmotif of his work is fair play. MacLean believes that beauty is contagious, that if we see it, we will want to replicate

it for others. His work is proof of cultural critic Elaine Scarry's contention that in the face of beauty, "We cease to stand even at the center of our own world. We willingly cede our ground to the thing that stands before us."* For Alex MacLean, that "thing" is the ground we play on. The rules we play by are the measure of our respect for it.

* Elaine Scarry, *On Beauty and Being Just* (Princeton, New Jersey: Princeton University Press, 1999), p. 112

IT IS HUMAN NATURE TO PLAY

Alex S. MacLean

My father studied the brain, specializing in brain evolution and behavior. He pointed out that one of the many differences between mammals and reptiles is that mammals, unlike reptiles, have a natural instinct and ability to play. He wrote that play starts at infancy with interactions between mother and child, and is of evolutionary importance for survival, learning, and socialization.[*] My father's teachings made me aware of the prominence of play in my life and the lives of those around me, and I have always been sympathetic to the need to play. Playing has inspired many of my photographs, some of which I have compiled for this book.

I fly alone in my Cessna, traveling on long cross-country flights or working on aerial photography projects that deal with environmental issues and urban planning. I have often deviated from my intended flight path to find relief, to

circle and wander, amusing myself by photographing for personal interests, making my own art. I have come to realize that this type of flying is my way of playing in the air, and I have discovered many interesting landscapes, many relating to play. In photographing these scenes I feel a sense of joy and often smile to myself as I see patterns and spaces on the ground that have been devoted to, built, adapted, or temporally used for play. As illogical as some of these patterns may be, they are ultimately positive expressions of human nature that have been documented clearly on the ground.

As people begin to have more time for leisure, there is a greater demand for spaces devoted to play, recreation, and amusement. Working against this demand for more space is the suburban sprawl, through which we are losing ready access to open lands and the freedom for children to roam. As a result, children are now driven to more organized and artificial places to play. These play spaces read as new and unnatural, and are a product of our time.

From the air, signs of play are everywhere. We see it clearly in backyards with swing sets, gardens, and swimming pools. We observe community parks and their ever-present baseball diamonds and basketball courts. Schools are recognized not so much by their buildings, but by their adjacent playgrounds

and athletic fields. University and college campuses have major indoor and outdoor play facilities. Prison yards are used for exercise and games like handball. In cities play is on a larger scale, with professional league stadiums and arenas, racetracks, major parks (including amusement parks), and often zoos.

Within these built landscapes, the competitive action of play involves control of territory and the possession of an object. There are offensive and defensive positions, drives and momentum, fakes and deception, steals and turnovers, all of which fall within the rules of the game. If not within the rules, an action is deemed out of bounds, out of play, or a foul, which is worthy of a penalty. The rules require built spaces marked and measured as territories, delineated in numerous ways with boundaries, borders, fields, courts, zones, goals, and penalty boxes.

Play usually incorporates the fourth dimension of time, which compresses an action within a set beginning and end. Unlike real-life situations, with play you can stop the clock. The dimension of time is apparent when the object of play is about speed, acceleration, and endurance, which take place across a given distance where landscapes are shaped into pathways, tracks, and obstacle courses. And, within all these arenas of play, we see a clear division between participants and spectators.

Perhaps the most satisfying thing about play is how it is able to adapt to different environments, responding to climate, soils, and topography. The desire to play despite these natural obstacles is so strong that we have used great ingenuity, inventing equipment and protective gear to expand the opportunities, places, and times we can play. We strap special equipment to our bodies so we can climb cliffs, ski, ice skate, snorkel, and we do this wearing special clothing, helmets, and lifejackets, all of which allow us to go to greater extremes. For others, different types of play, such as pond-hockey, fishing, or surfing, can depend on the season as well as a region's character. In this way, play is also an important link to environmental awareness.

One does not need to look far to find evidence of people at play. It keeps us in touch with our minds, bodies, and spirits. My father always spoke of play's "civilizing influence in human evolution," and it is in play that we leave some of our better marks and traces on the earth's surface.

*Paul D. MacLean, *The Triune Brain in Evolution: Role in Paleocerebral Functions* (New York: Plenum Press, 1990), pp. 396–397

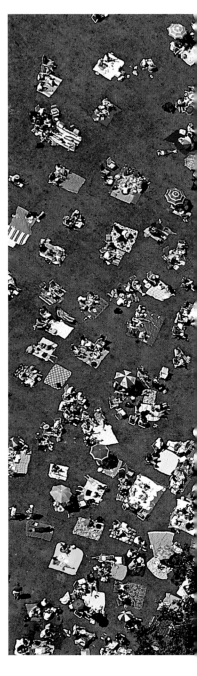

Picnickers listening to live concert at Tanglewood Lenox, MA, July 1996

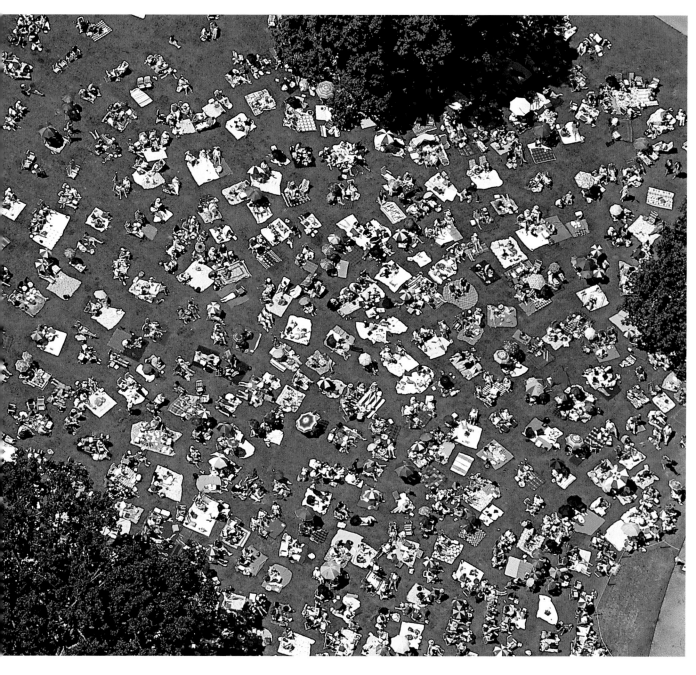

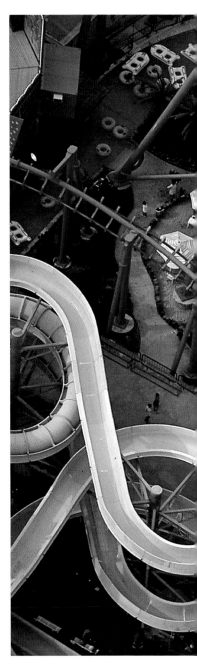

Interwoven structures for roller coasters and waterslides Ocean City, NJ, July 1996

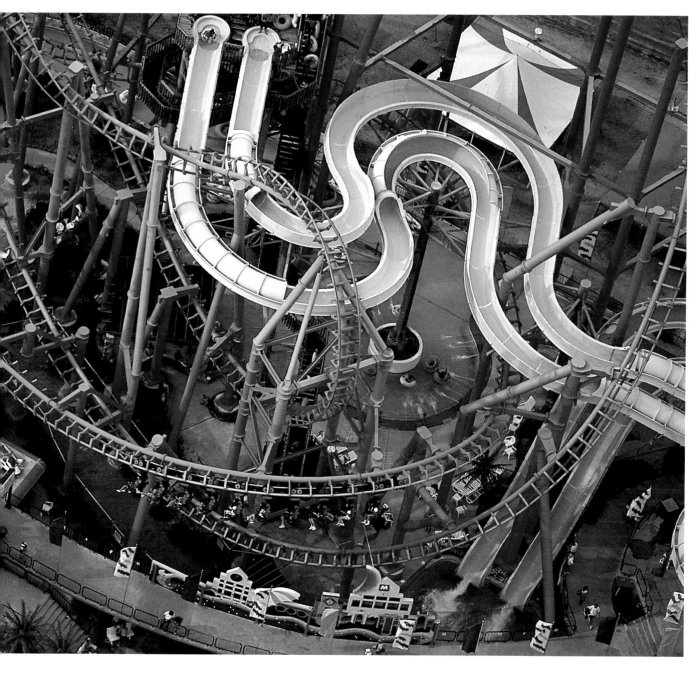

Walt Disney World, Grand Canyon Ride Orlando, FL, April 1999

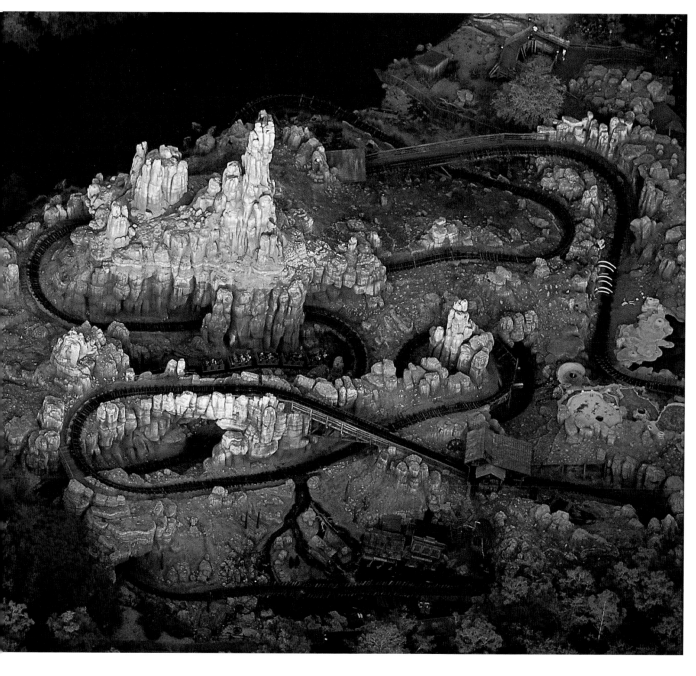

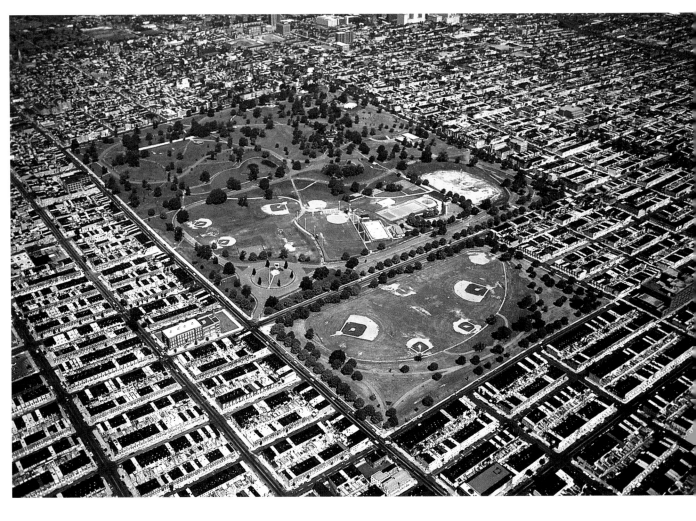

City park with large service area of row houses Baltimore, MD, July 1981

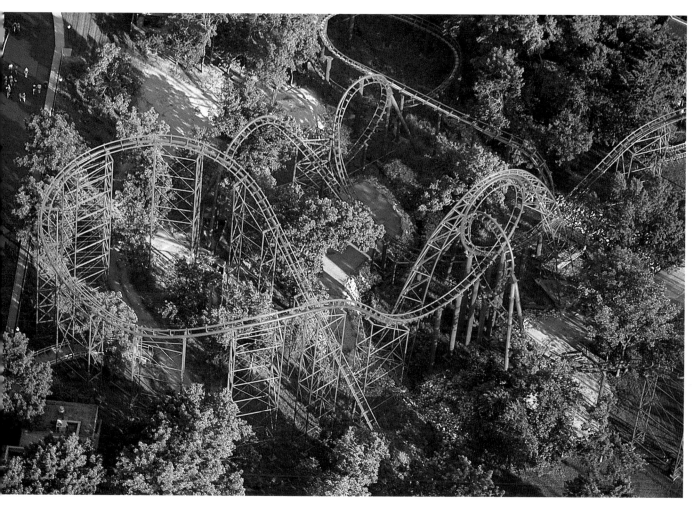

Intertwined red roller coaster Kansas City, MO, June 2002

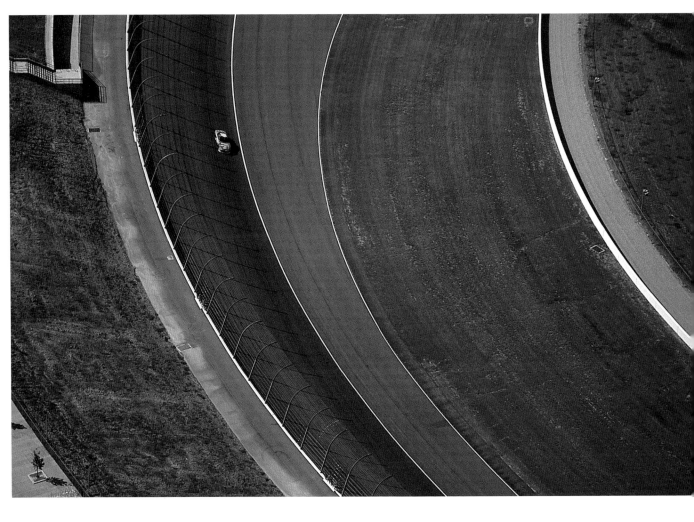

Race car banking on Kansas City Speedway Kansas City, KS, May 2002

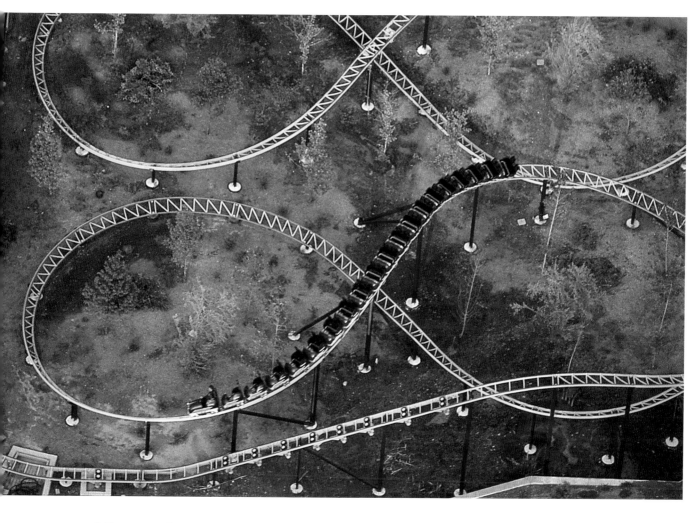

Roller coaster ride Springfield, MA, May 2001

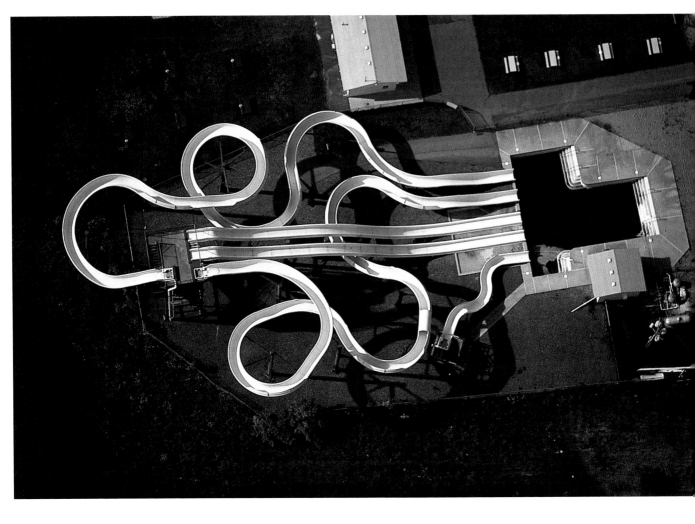

Off season waterslide Southeastern MA, October 1994

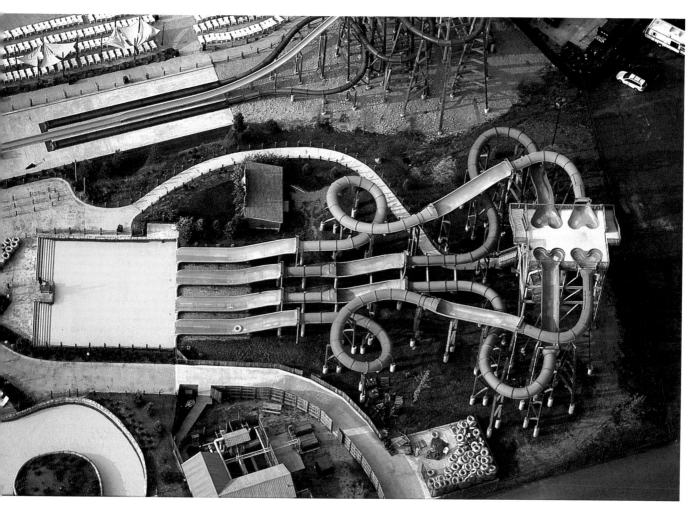

Waterslide with colored chutes Springfield, MA, May 2001

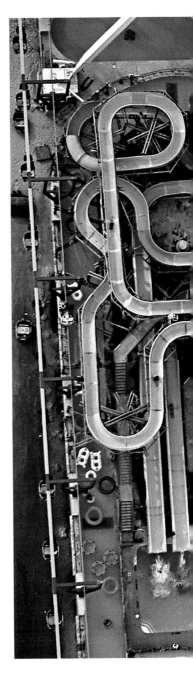

Twists and turns of waterslide park Jersey Shore, NJ, July 1996

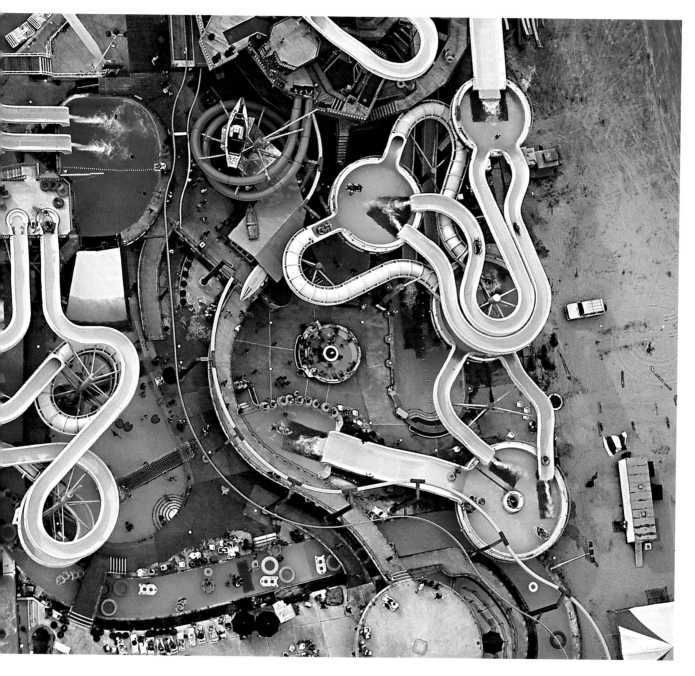

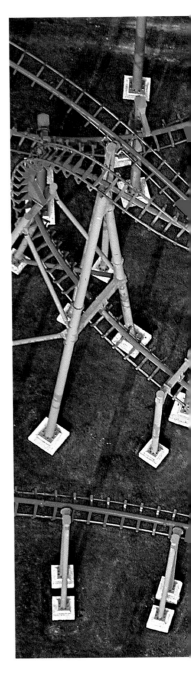

"Superman Ride of Steel" Springfield, MA, May 2001

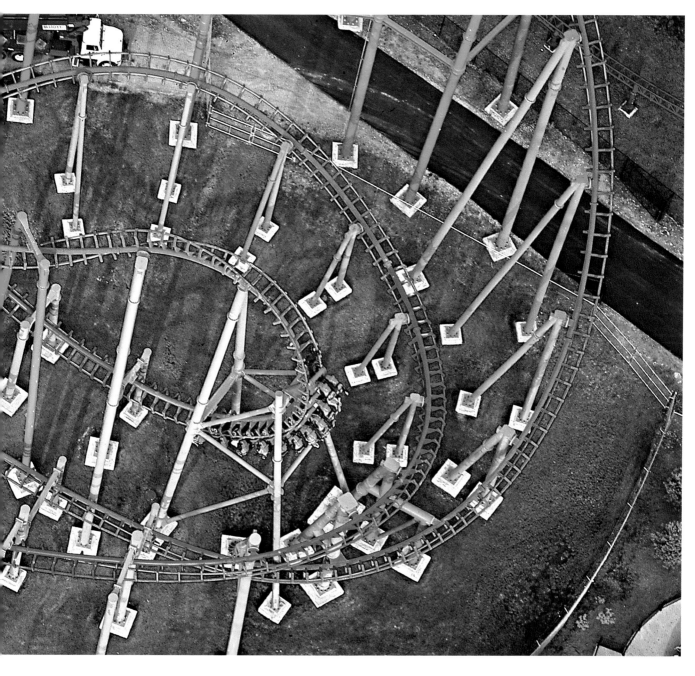

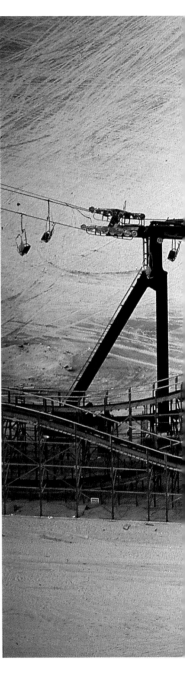

Roller coaster extending out over beach Wildwood, NJ, July 1996

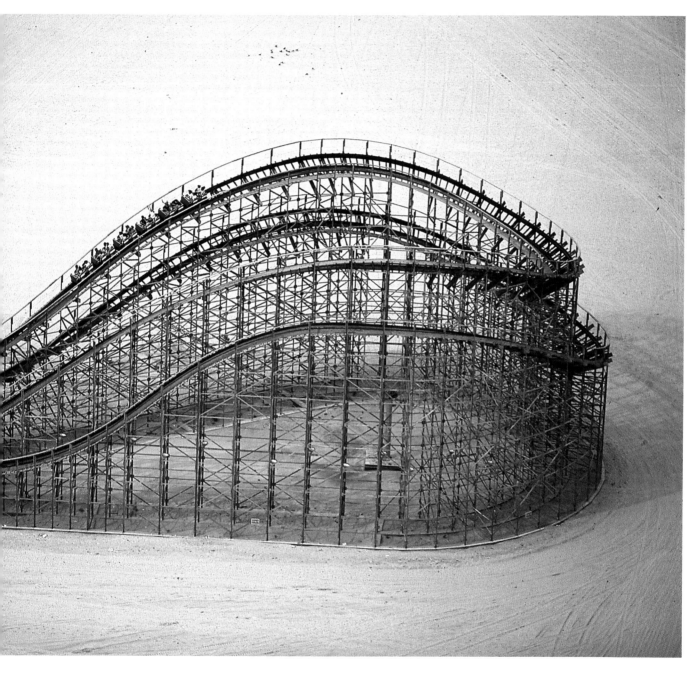

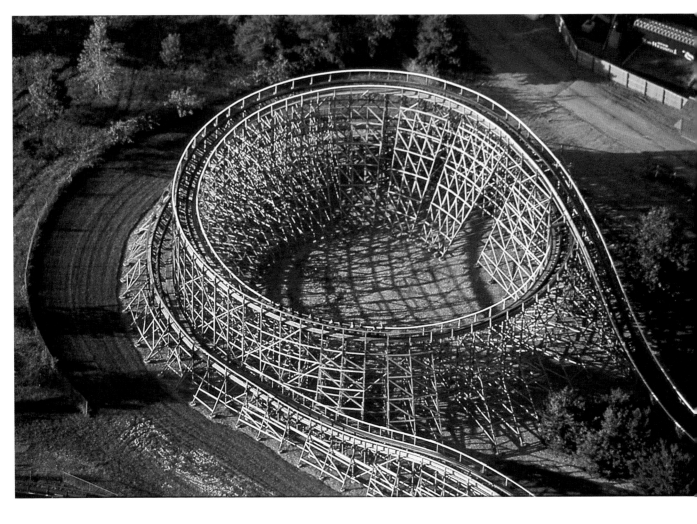

Roller coaster with wood frame Kansas City, MO, May 2002

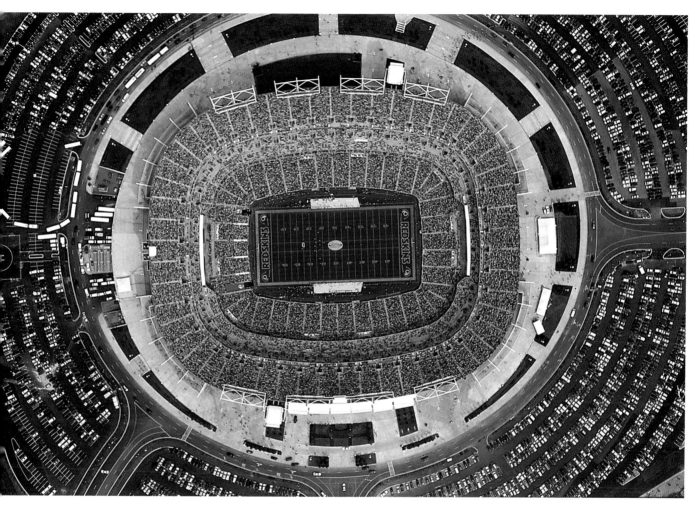

Redskins Football Stadium, playing field to parking lot Mitchellville, MD, September 1997

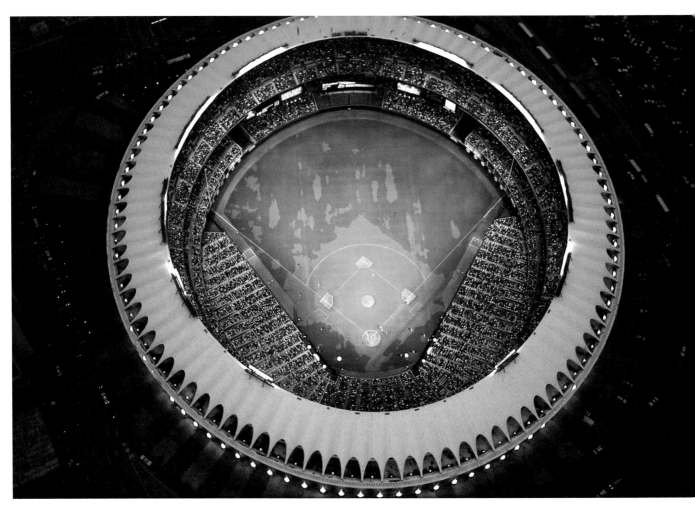

Wet astro-turf, night game at Bush Stadium St. Louis, MO, October 1987

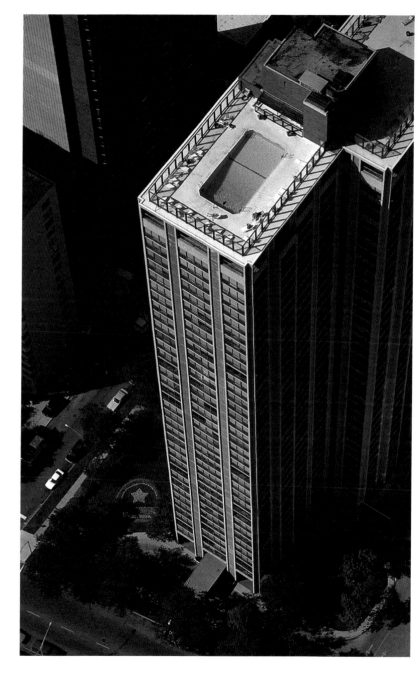

Lakeshore Drive penthouse pool Chicago, IL, August 1990

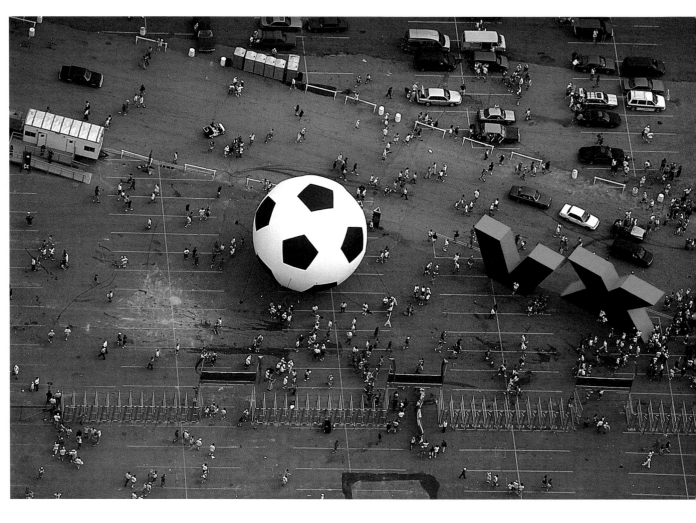

World Cup soccer fans pass through gate, Foxboro Stadium Foxboro, MA, August 1994

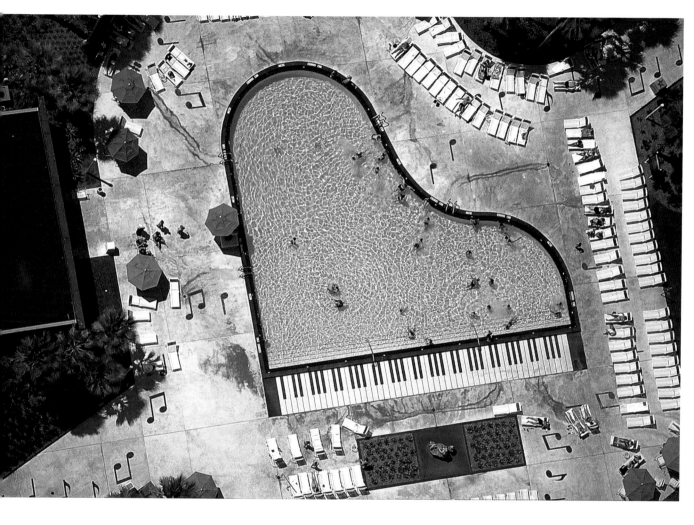

Theme motel with piano pool Orlando, FL, April 1999

Theme motel with guitar-shaped pool Orlando, FL, April 1999

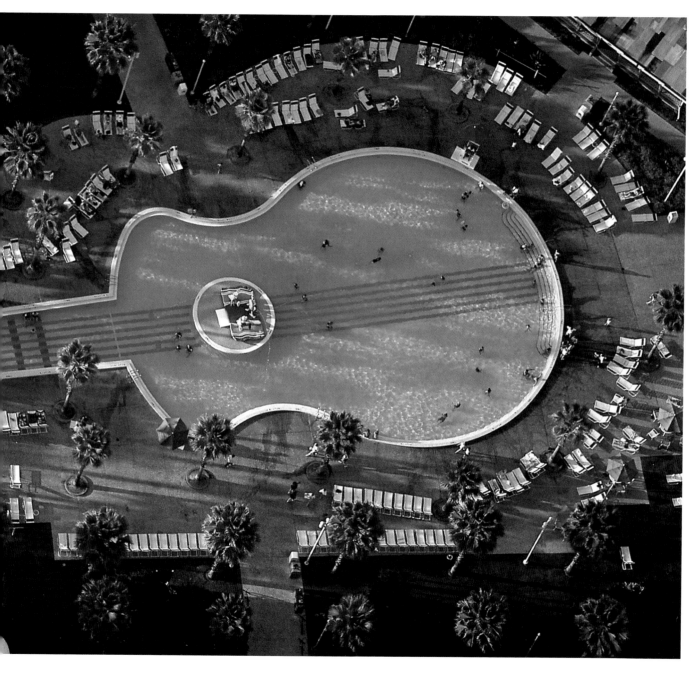

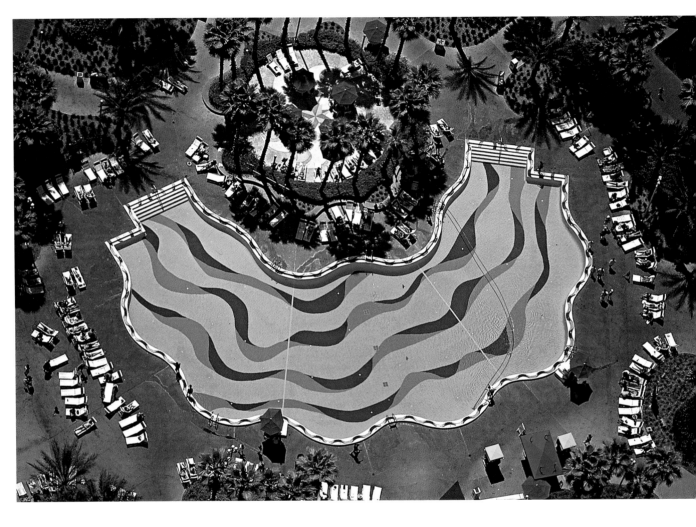

Tile wave pool Orlando, FL, April 1999

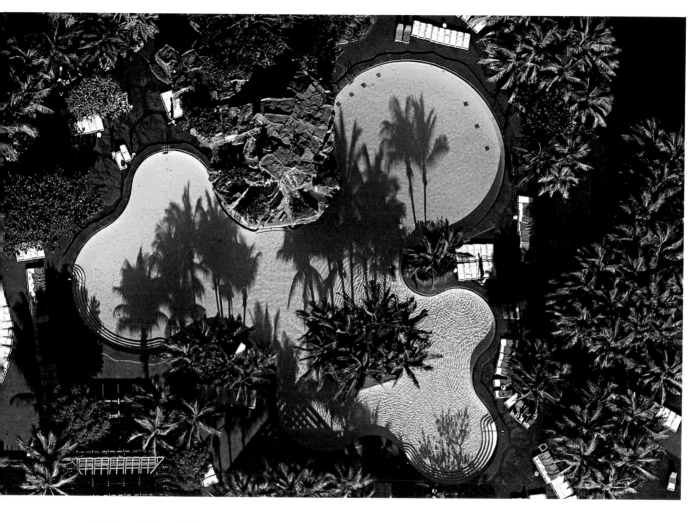

Hotel poolside oasis Miami Beach, FL, April 1986

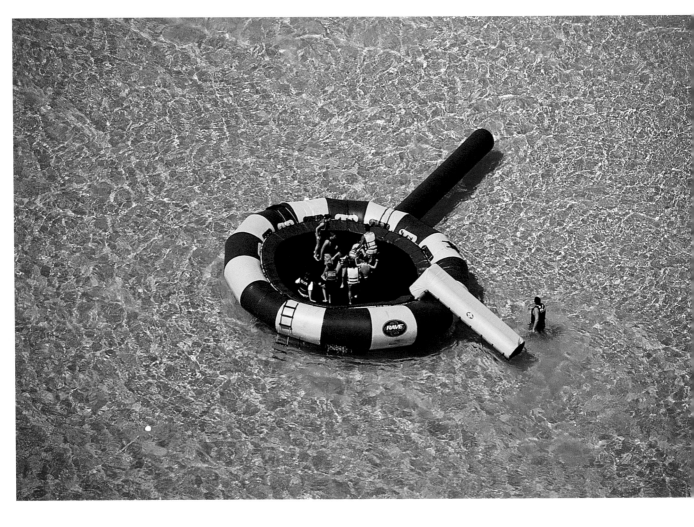

Giant water tube with slide Seaside, FL, March 2002

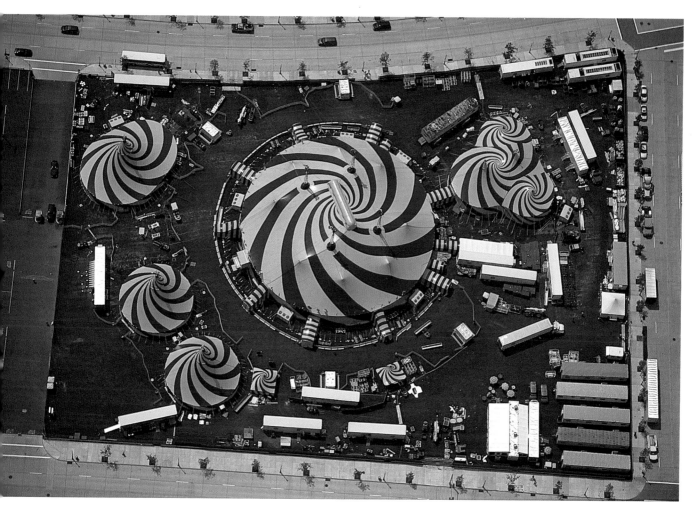

Circus tent tops Pittsburgh, PA, June 2002

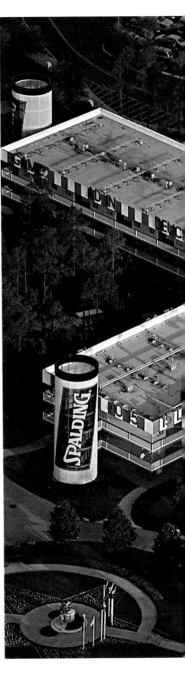

Theme motel, tennis courtyard Orlando, FL, April 1999

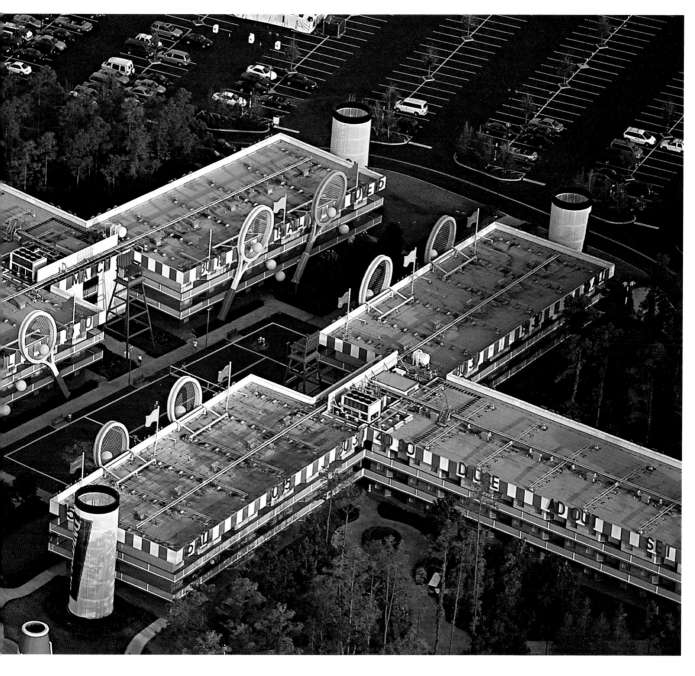

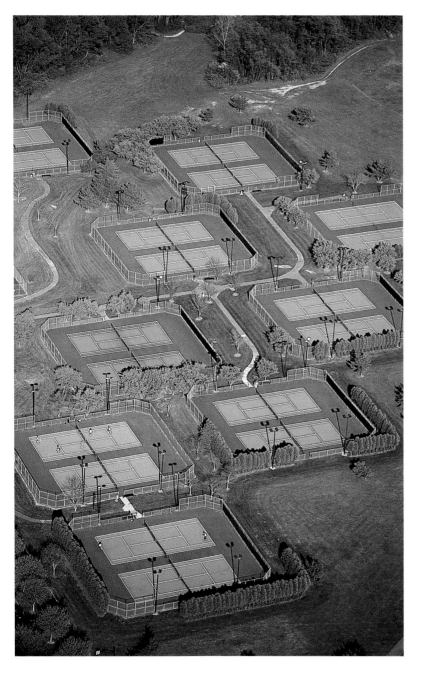

Public tennis courts Southern NJ, April 2000

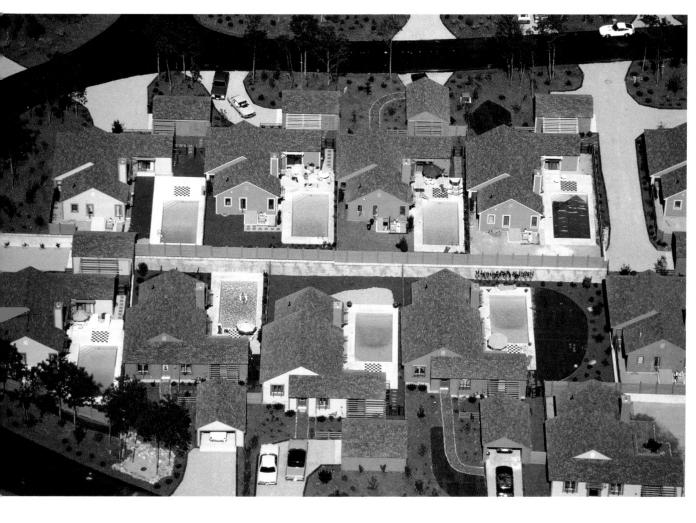

Identical private backyard pools New Seabury, MA, July 1981

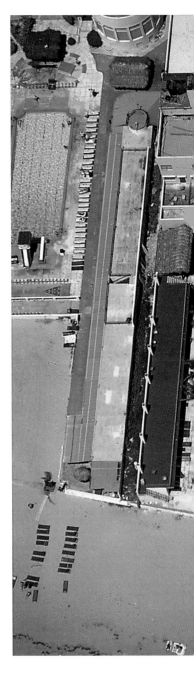

Art Deco hotel pools Miami Beach, FL, May 1980

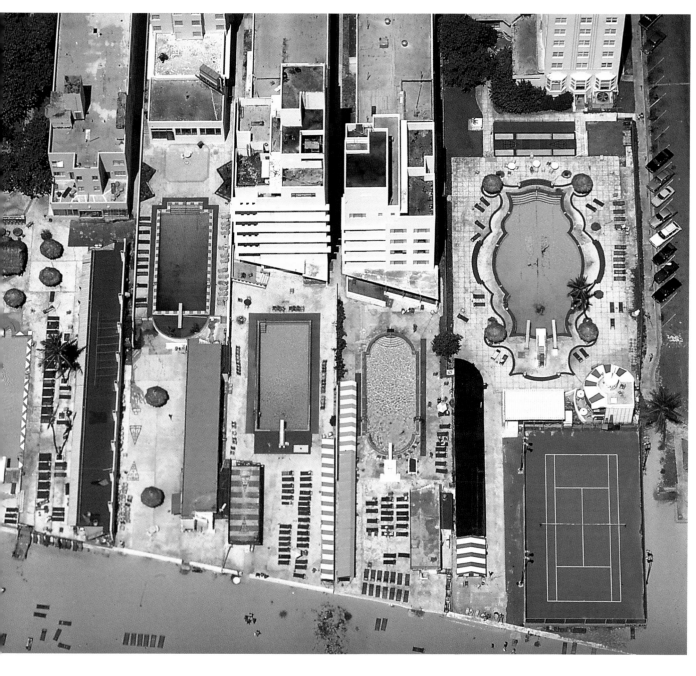

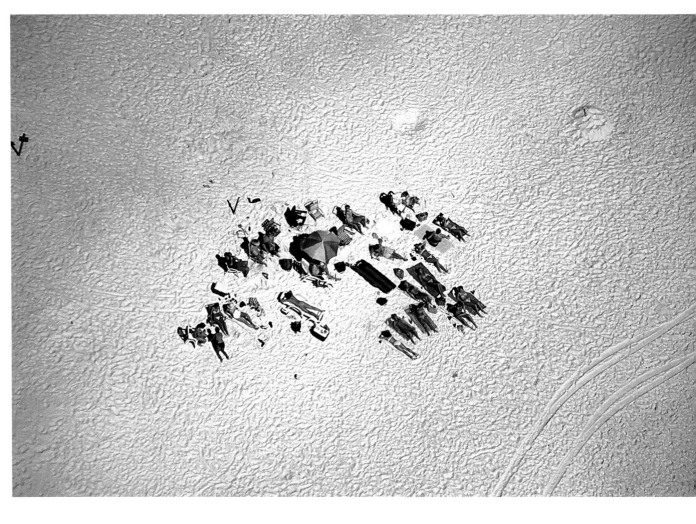

Sunbathers on Santa Rosa Beach Santa Rosa Beach, FL, March 2002

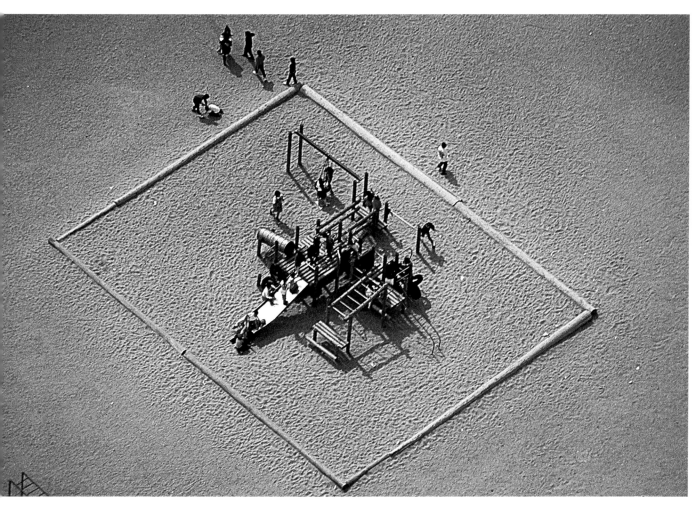

Desert playground jungle gym El Paso, TX, March 1994

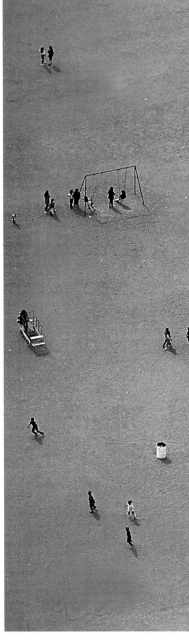

Desert playground jungle gym and other play equipment El Paso, TX, March 1994

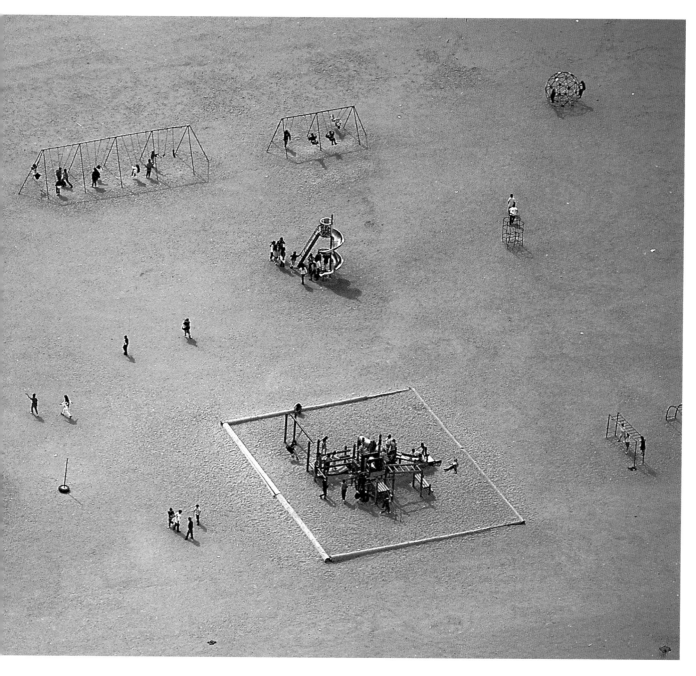

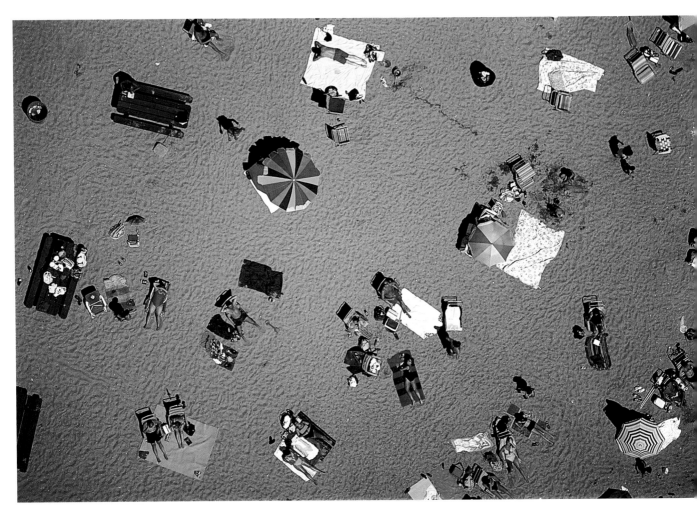

Sunbathers on Long Island Sound Milford, CT, July 1998

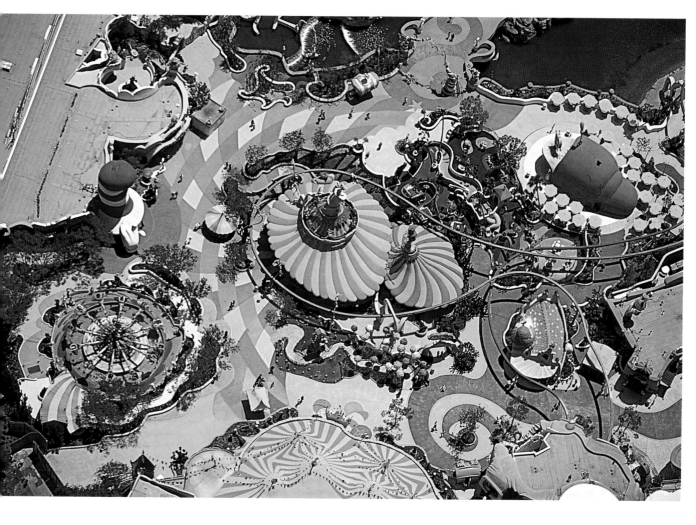

MGM Studios pedestrian walks and amusement rides Orlando, FL, April 1999

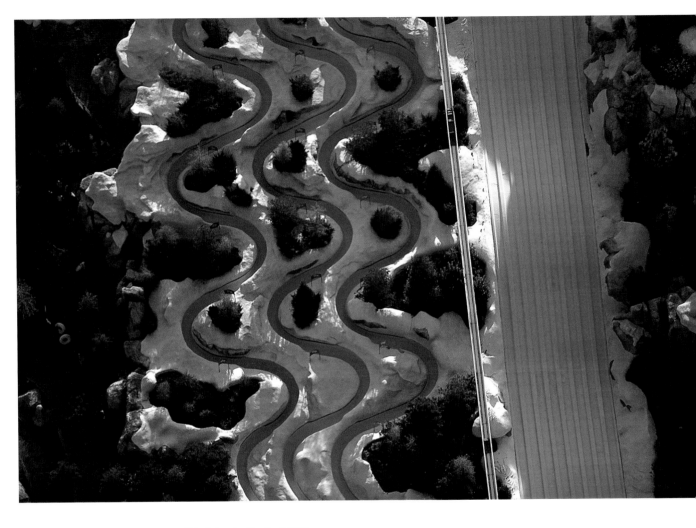

Alpine waterslide Orlando, FL, April 1999

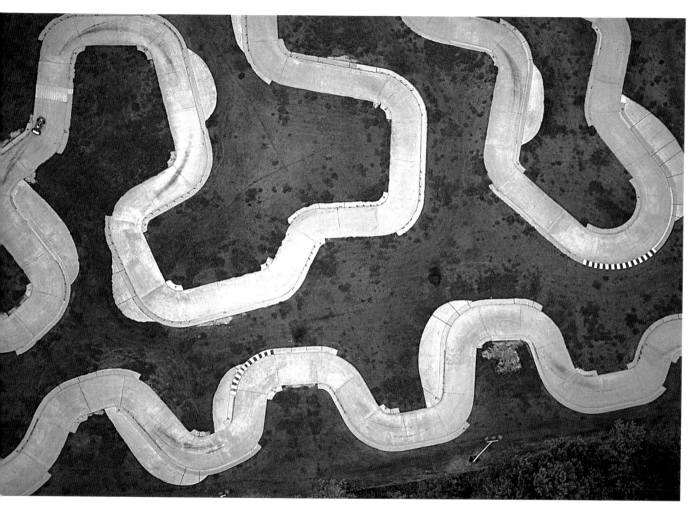

Go-cart raceway with spin-out corners Central NJ, June 1995

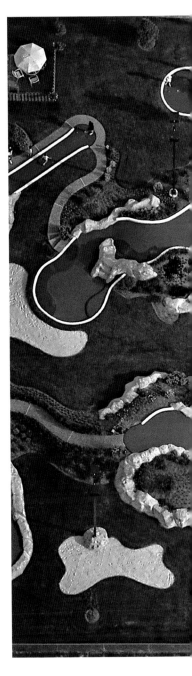

Pathways and links, miniature golf course Central NJ, June 1990

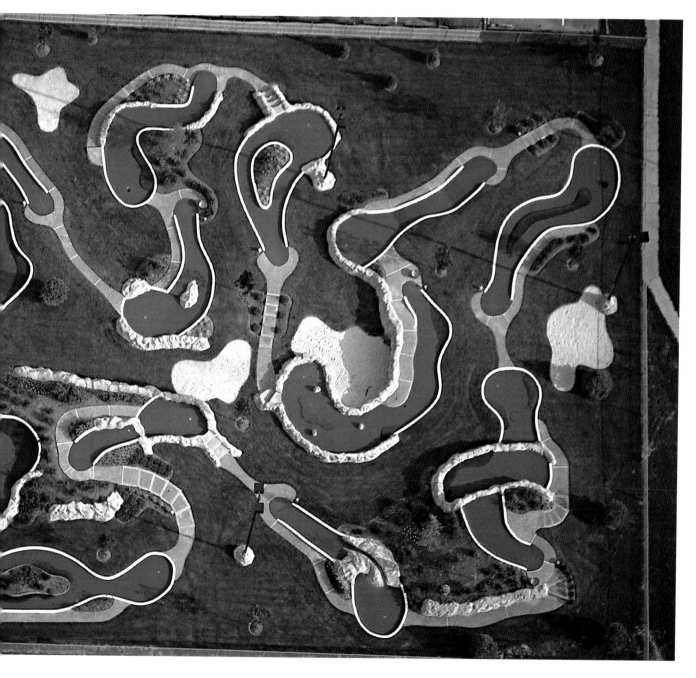

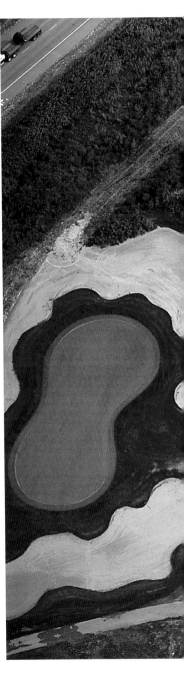

Sand bunker with nautical anchor and star Chicago, IL, October 1996

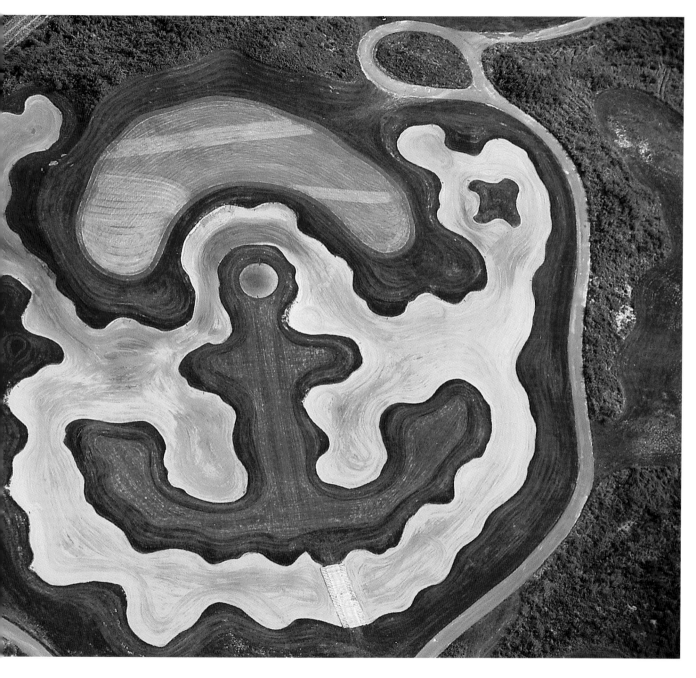

Prison handball court Bridgewater, MA, April 2001

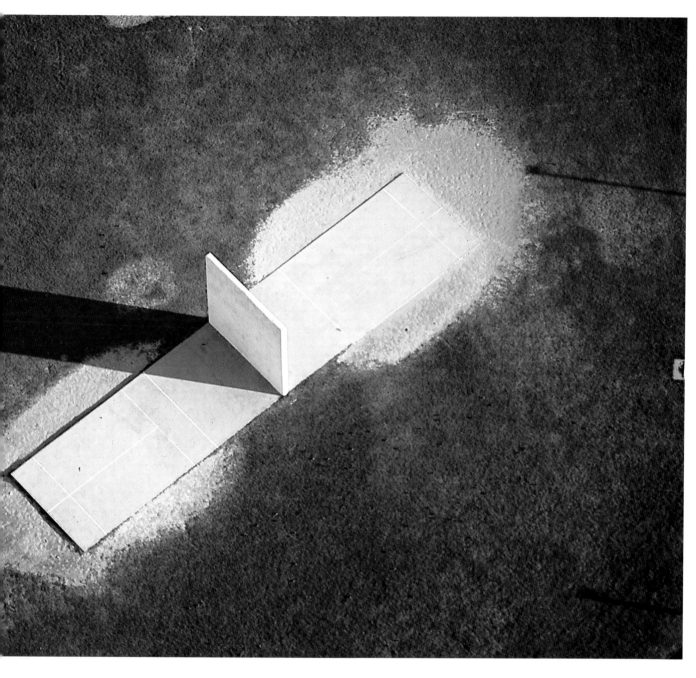

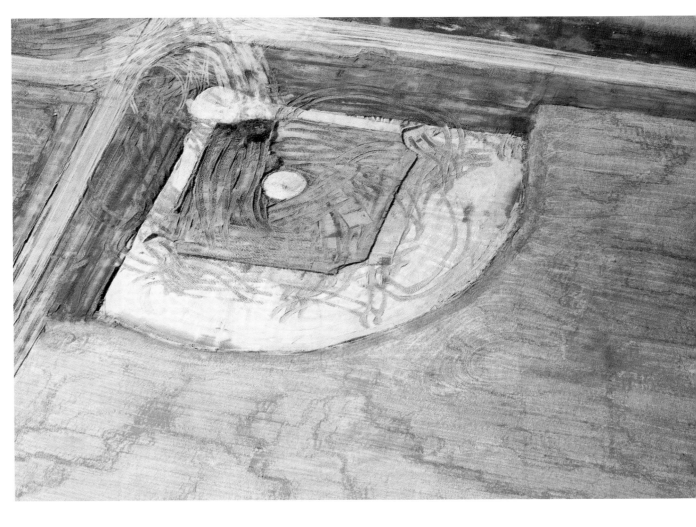

Baseball diamond under construction Westborough, MA, October 2004

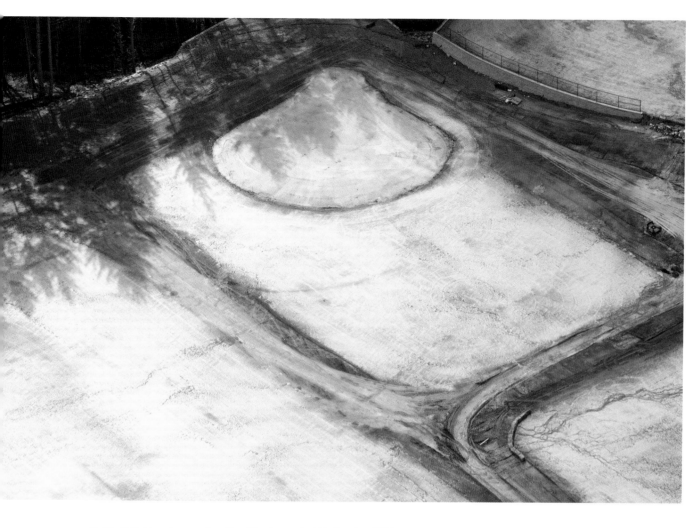

Softball field under construction Westborough, MA, October 2004

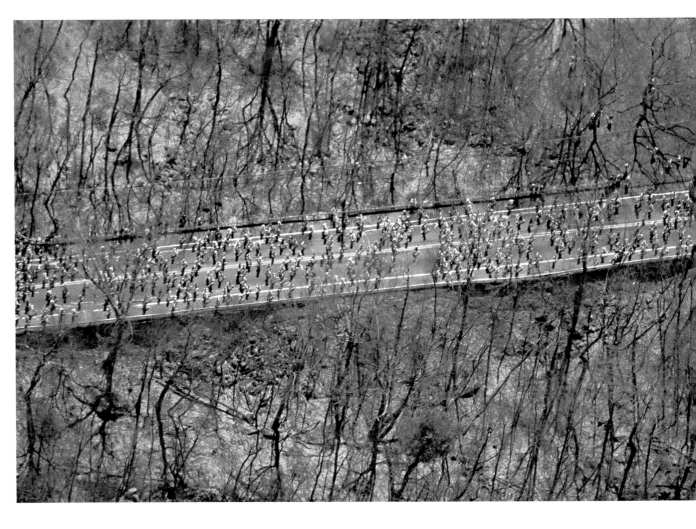

Runners on Boston Marathon course Hopkinton, MA, April 1995

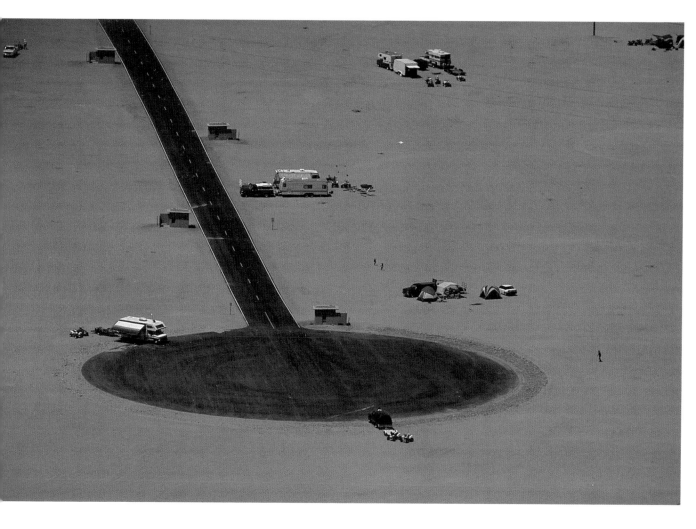

Desert loading pod for ATVs (all terrain vehicles) and dune buggies Yuma, AZ, April 1994

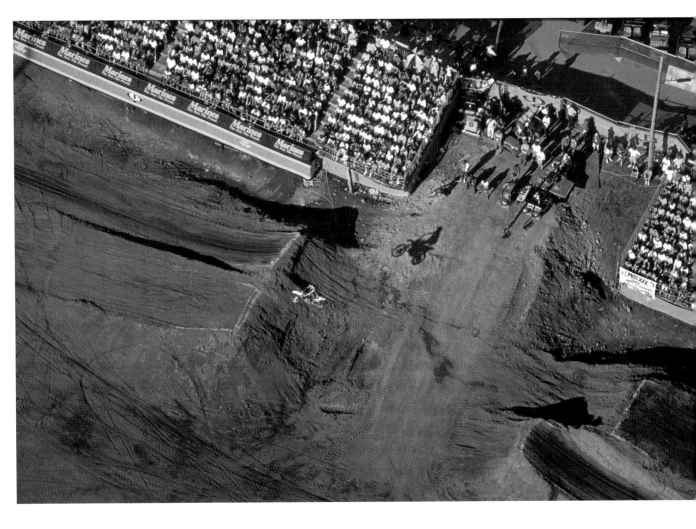

Dirt bike jumps, Gravity Games Providence, RI, September 1999

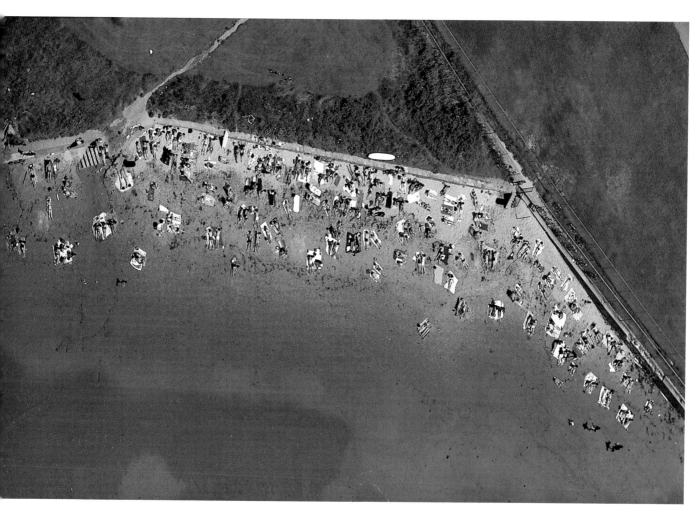

Sunbathers Newport, RI, June 1982

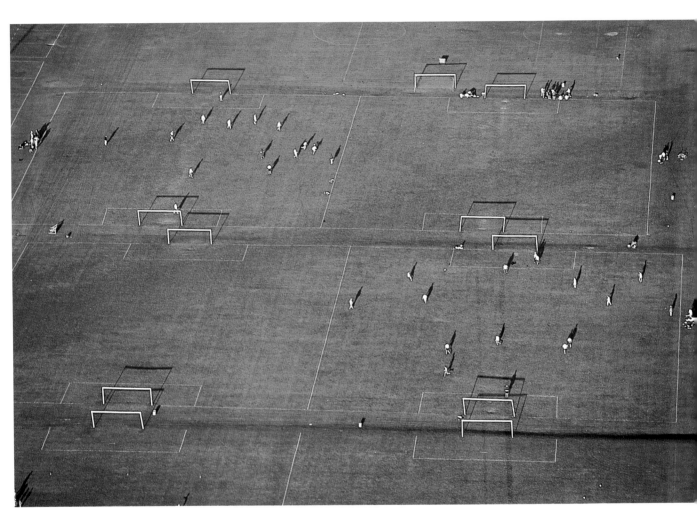

Soccer fields Amherst, MA, October 1992

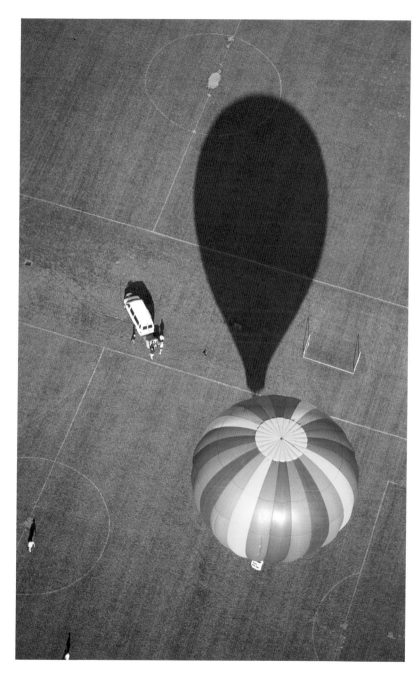

Balloon shadow Columbus, OH, June 2000

Line markings for parking lot and basketball courts Waltham, MA, March 1994

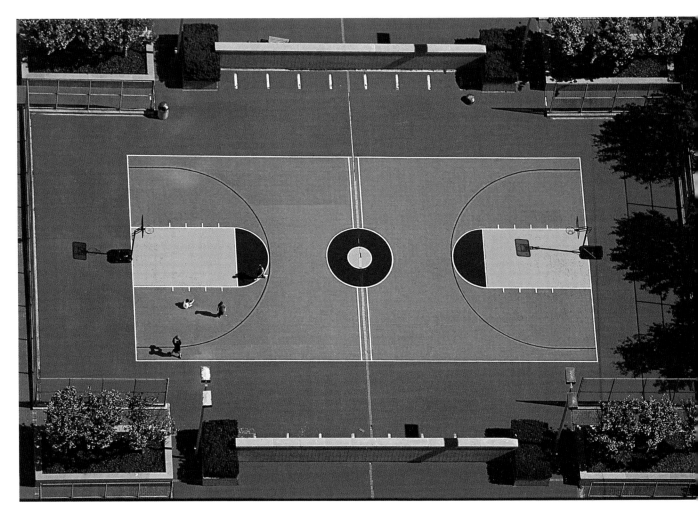

Blue basketball court with colored zones Atlantic City, NJ, April 2000

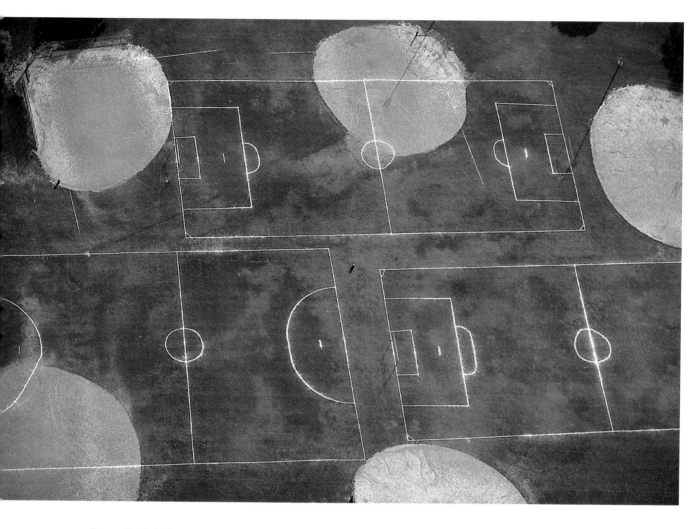

Soccer fields laid over softball diamonds Chicago, IL, October 1995

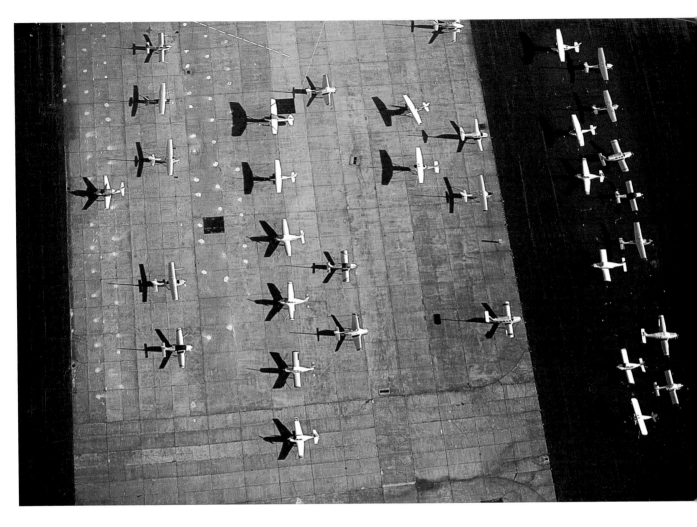

Parked recreational planes on tie-down apron Bedford, MA, September 1999

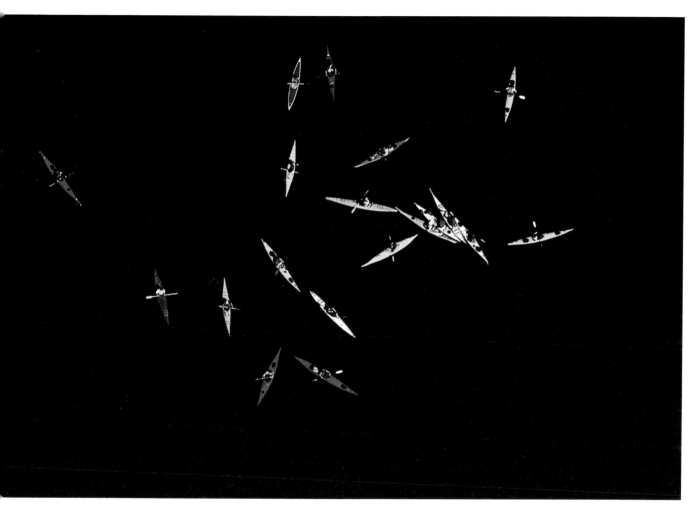

Kayaks gather on Walden Pond Concord, MA, May 2001

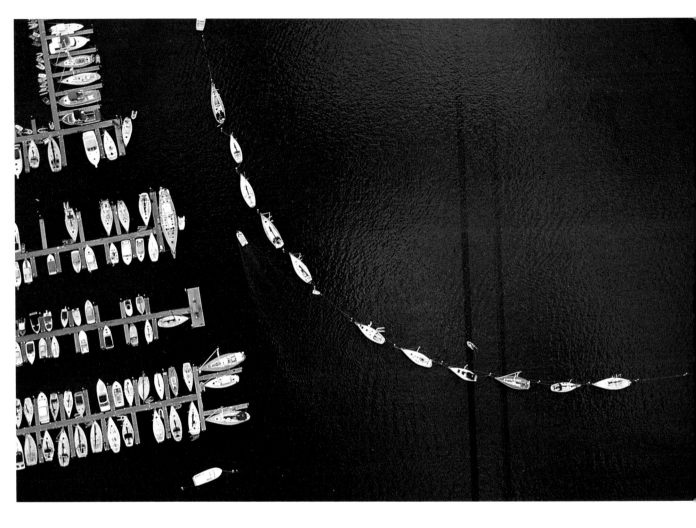

Boat sterns from pilings Wickford Harbor, RI, September 1998

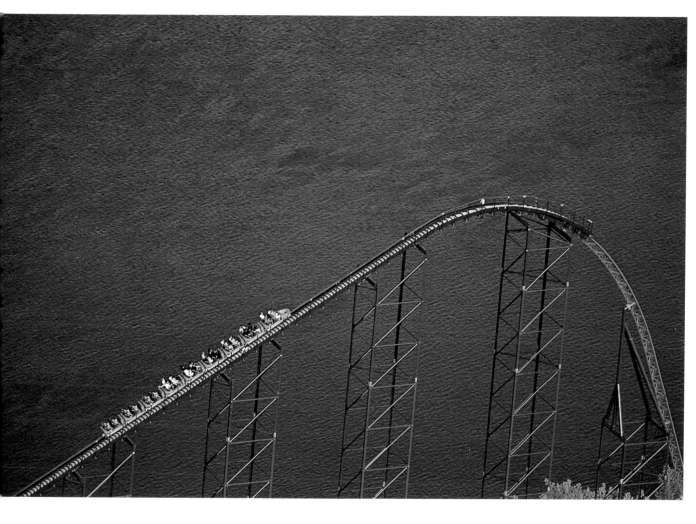

Climbing toward the big drop off Springfield, MA, May 2001

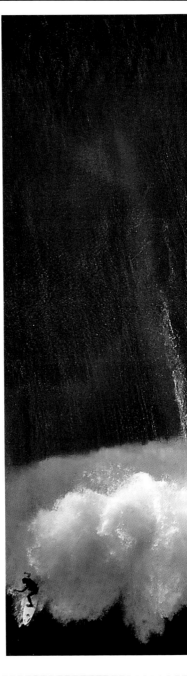

Sunset Beach, surfers behind breaking waves Oahu, HI, March 1998

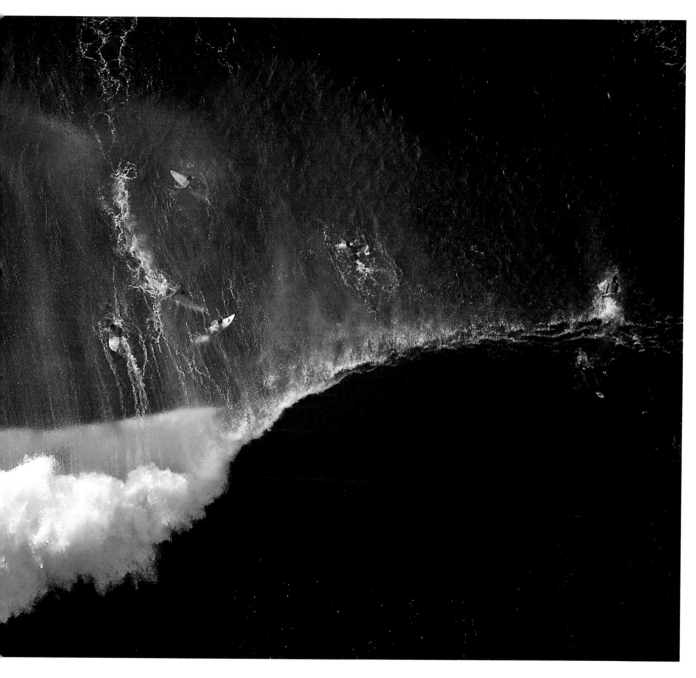

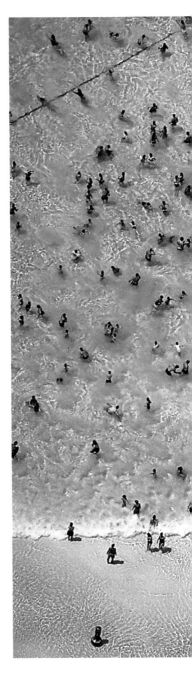

Wave pool Orlando, FL, April 1999

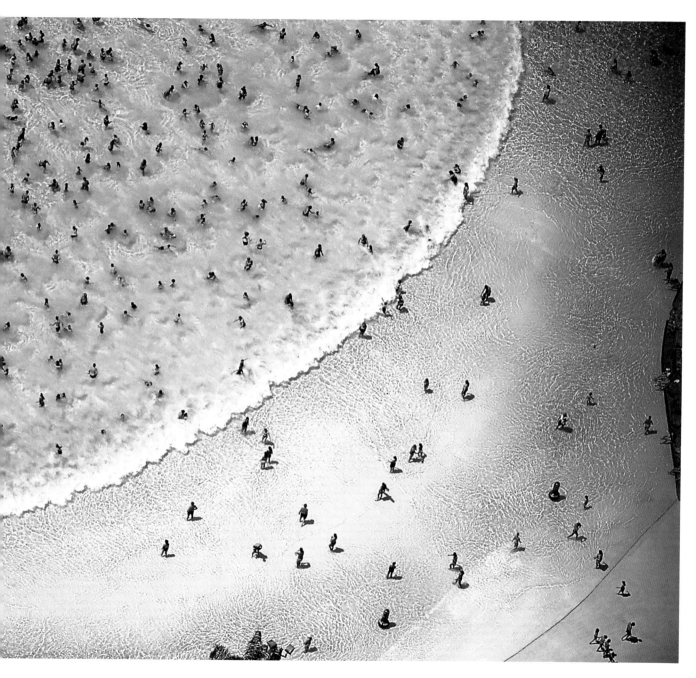

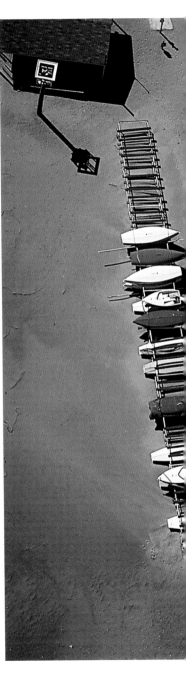

Racks of sunfish on beach edge Evanston, IL, March 1997

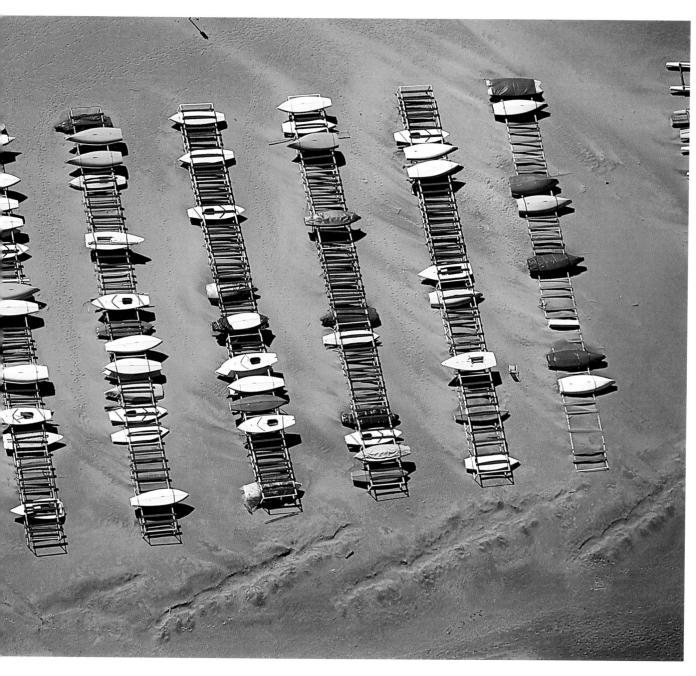

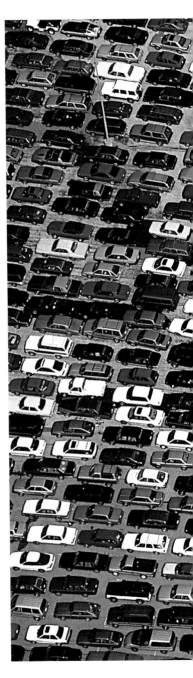

No escape parking for baseball game at old Memorial Stadium
Baltimore, MD, April 1990

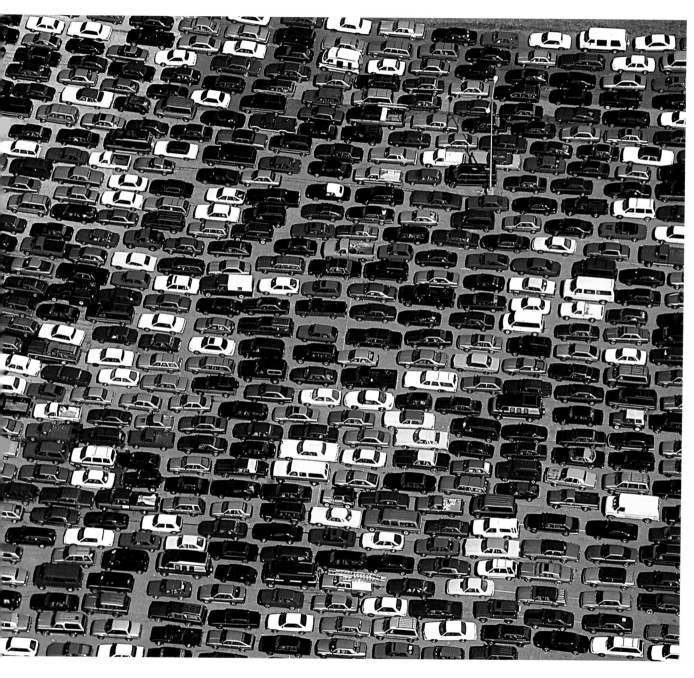

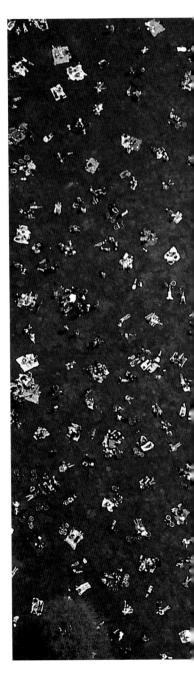

Central Park picnickers New York, NY, April 1997

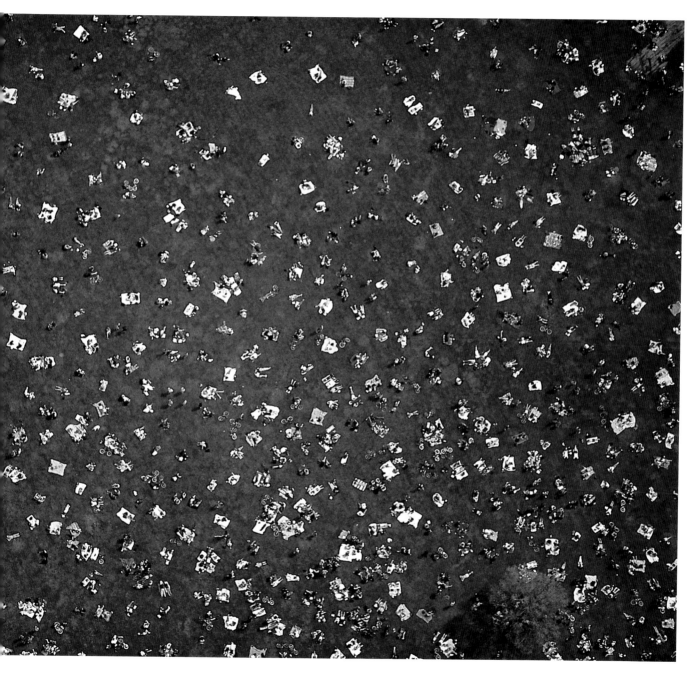

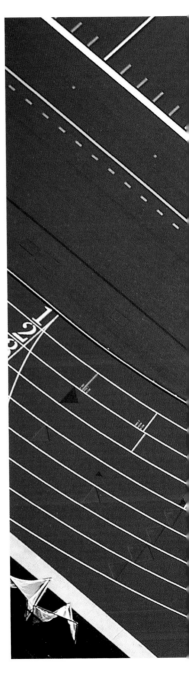

Pep talk on synthetic infield West Point, NY, October 1998

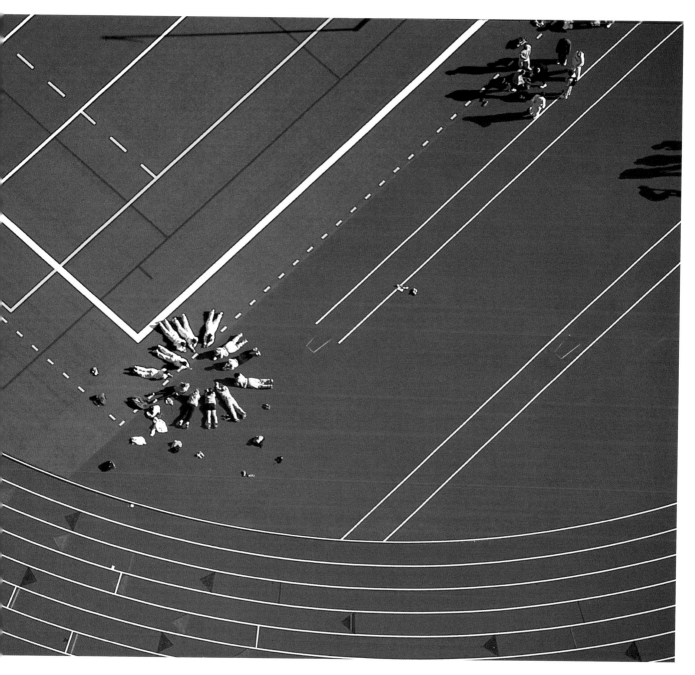

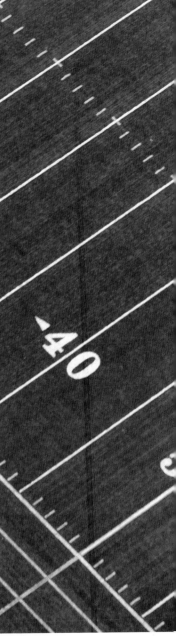

Overlapping football and soccer line markers North Andover, MA, September 2005

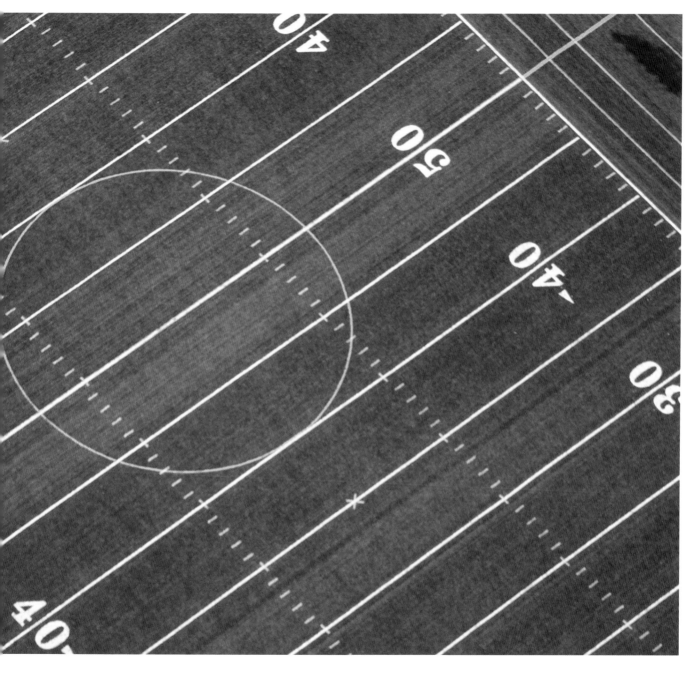

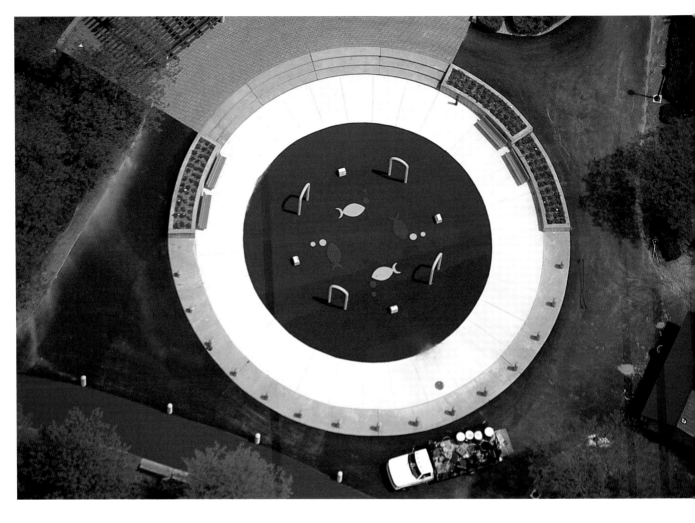

Playground with new artificial play surface and sitting area Watertown, MA, May 2000

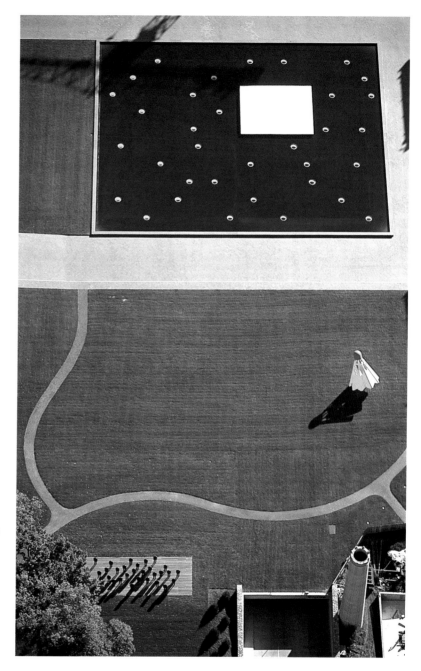

Shuttlecocks and sculptures at Nelson-Atkins sculpture park Kansas City, MO, October 2002

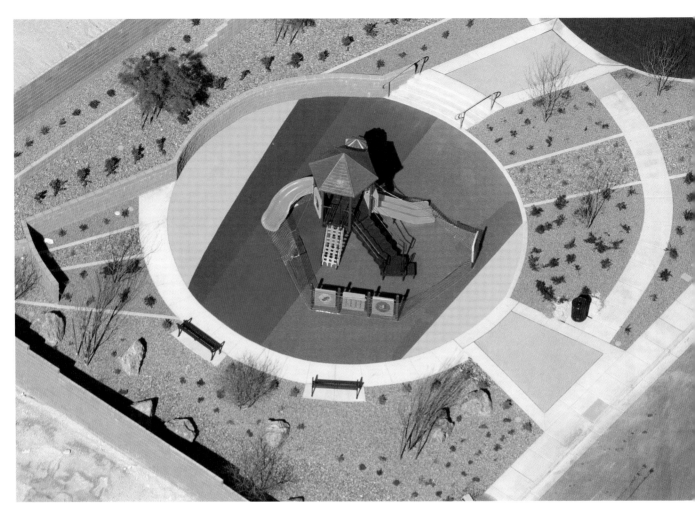

Play park with a plastic center Las Vegas, NV, March 2005

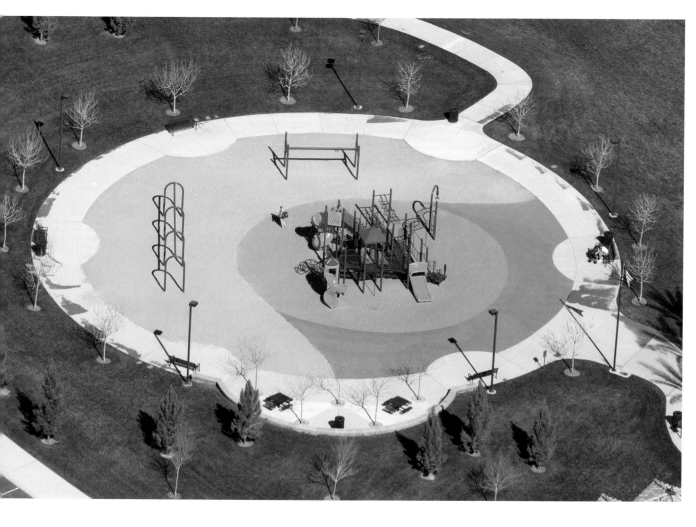

Private playground for new housing subdivision Las Vegas, NV, May 2003

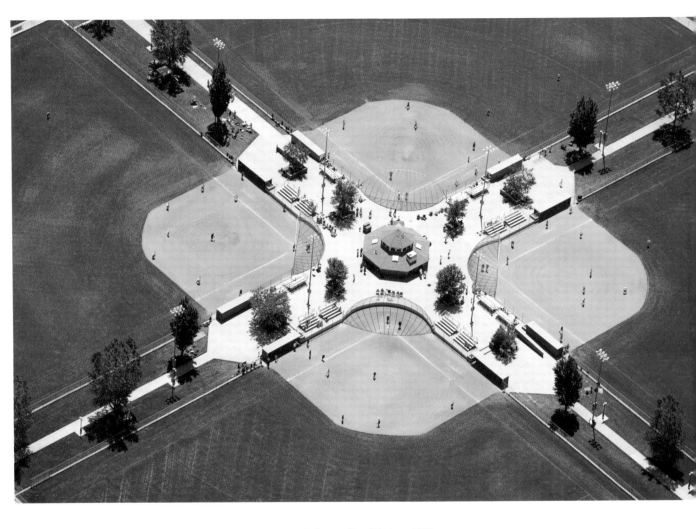

Baseball park with diamonds back to back Centerville, UT, June 2005

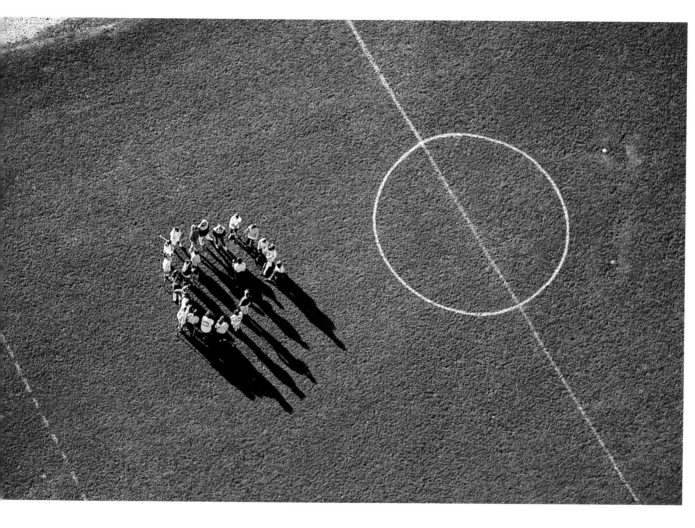

Team huddles near center field Bethel, ME, October 1992

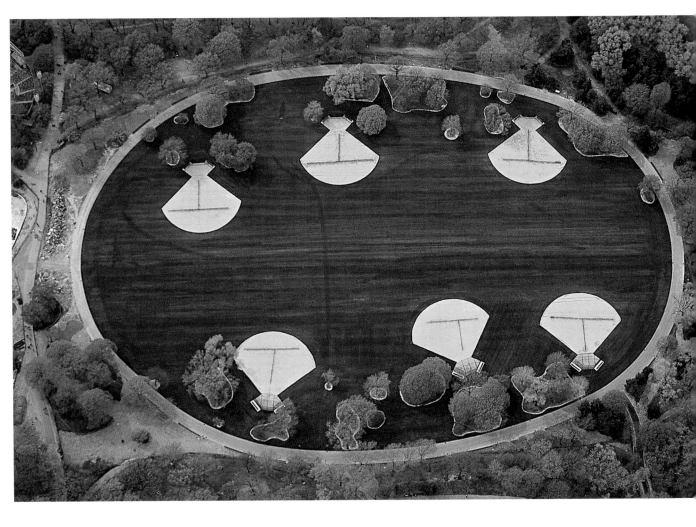

Central Park softball diamonds on the great lawn New York, NY, April 1997

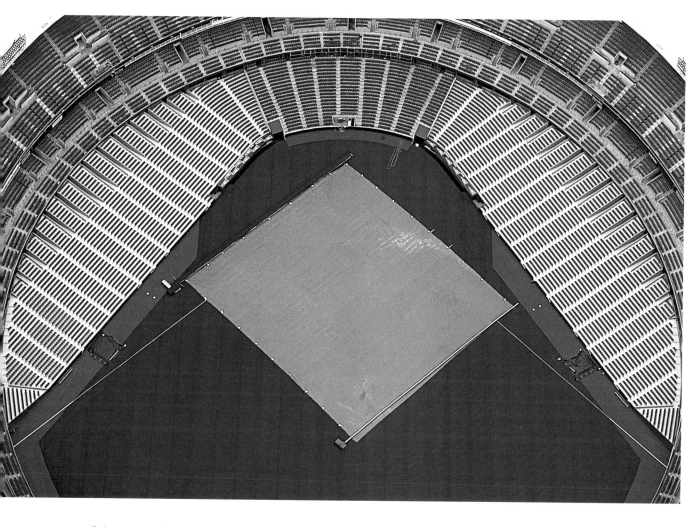

Rain tarp over infield at Bush Stadium St. Louis, MO, July 1991

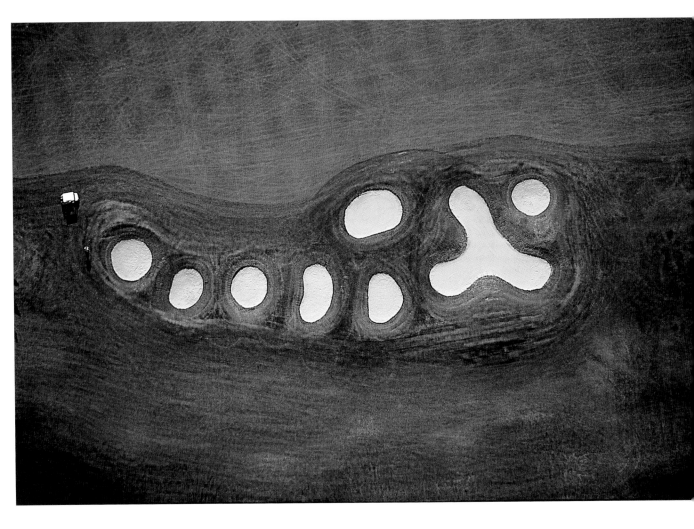

Hazards-sand bunkers along fairway Manchester, VT, June 1995

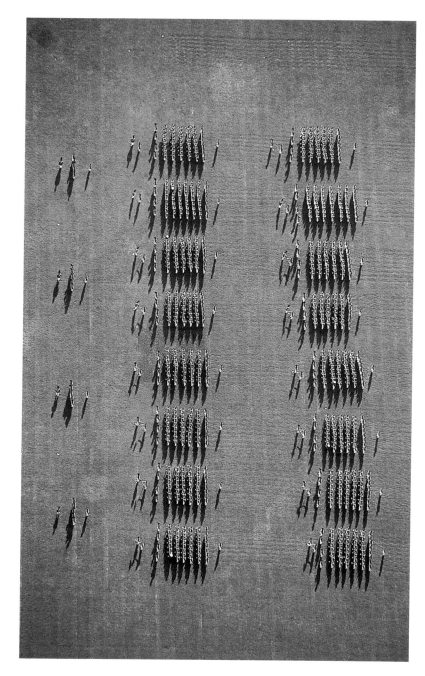

Army cadets on parade ground
West Point, NY, October 1998

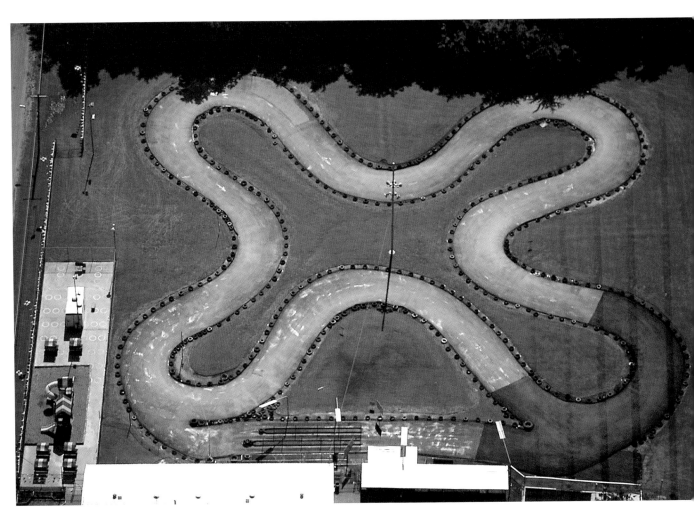

Go-cart racetrack configured to maximize length Dallas, TX, May 2002

Unmarked tennis courts Manchester, NH, May 1998

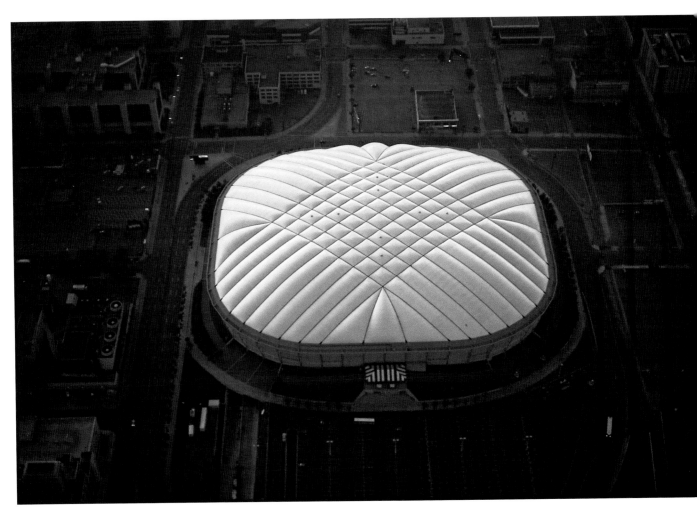

Domed stadium to watch outdoor sports Minneapolis, MN, July 1989

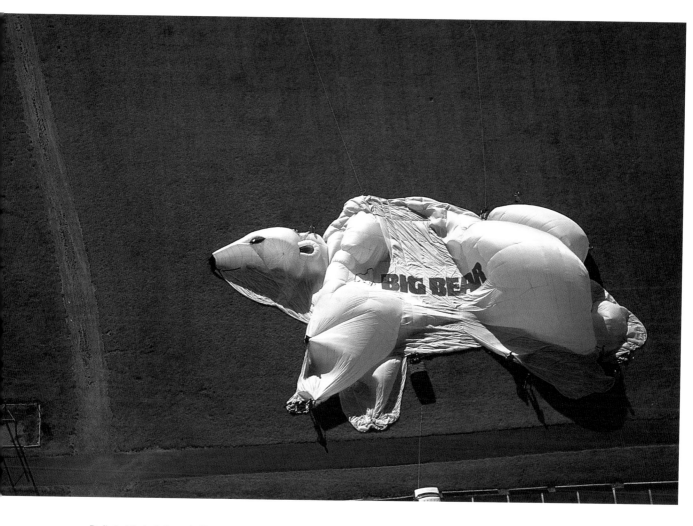

Deflated hot air bear balloon Columbus, OH, June 2000

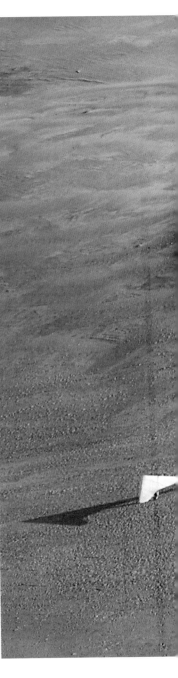

Hang-gliders launching off dunes on Outer Banks Nags Head, NC, March 1991

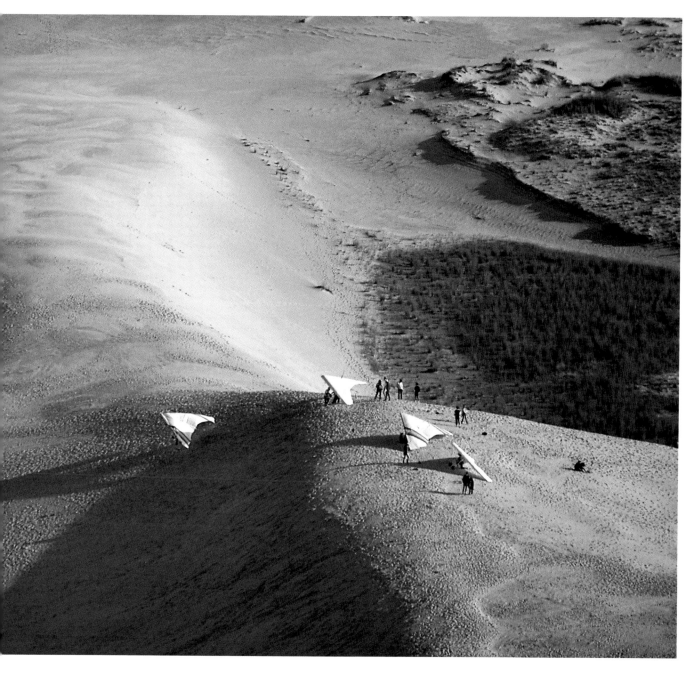

Ice fishing holes and tracks Westborough, MA, February 1998

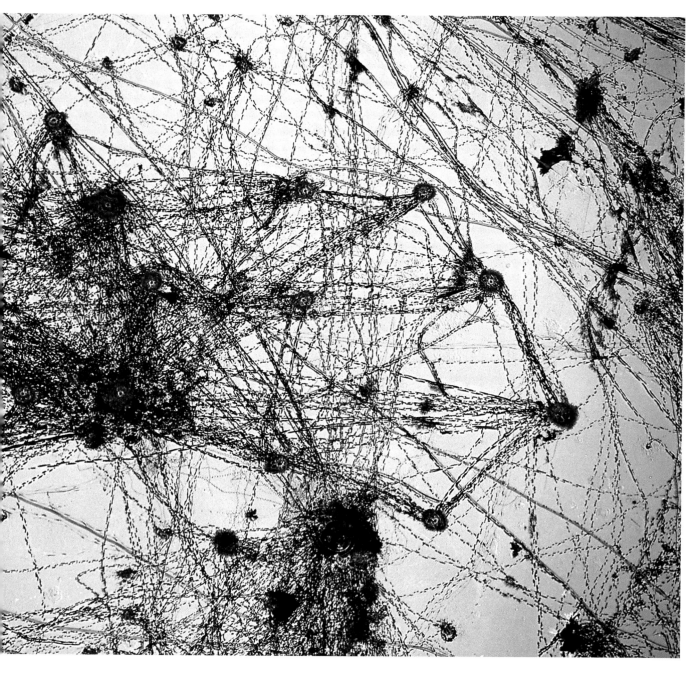

Motorcycle racing on black ice Southeastern MA, February 1989

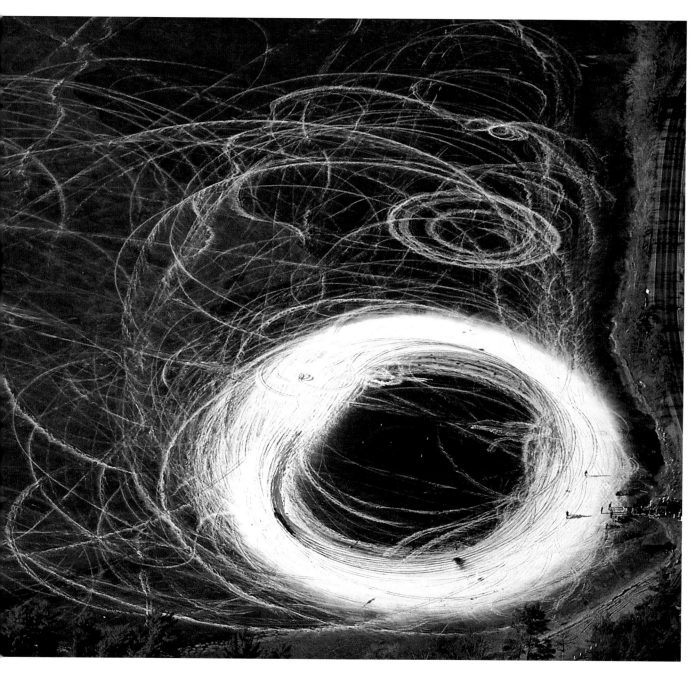

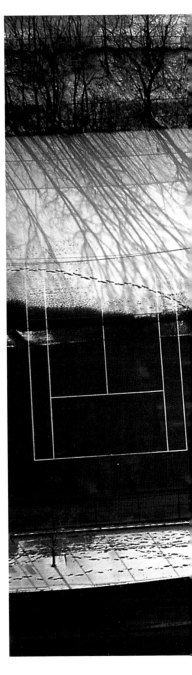

Snow drifts over tennis and basketball courts Deerfield, MA, February 1999

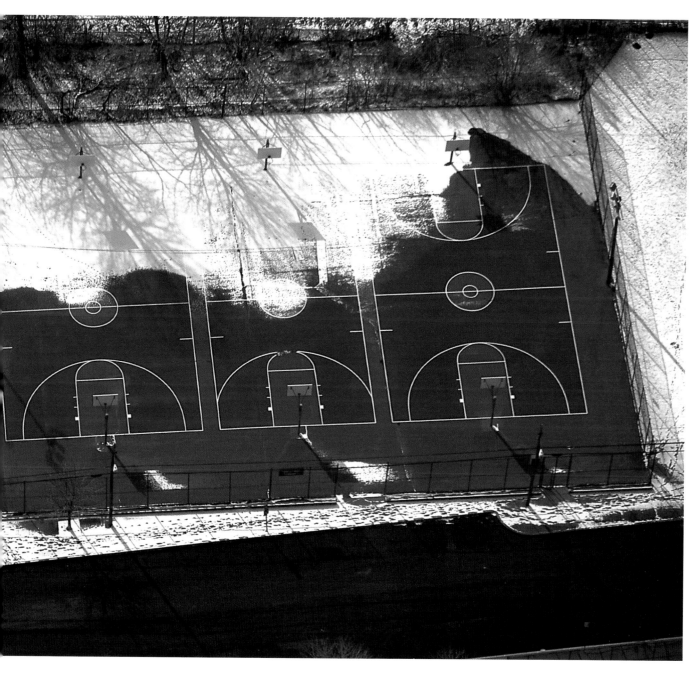

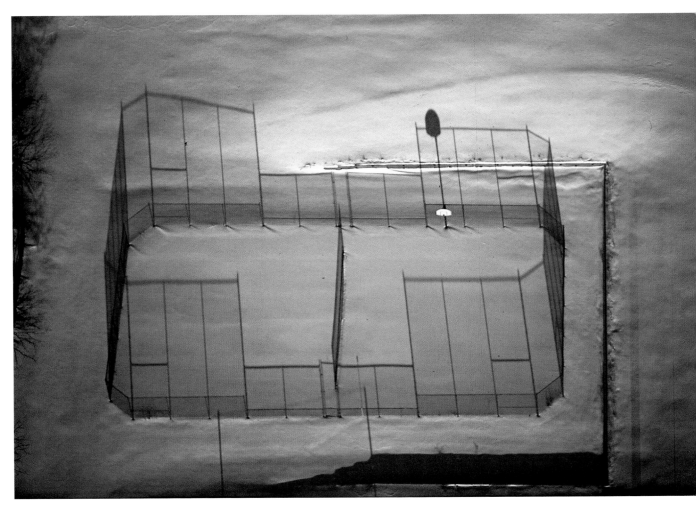

Winter shadows define tennis and basketball courts Cambridge, VT, December 1995

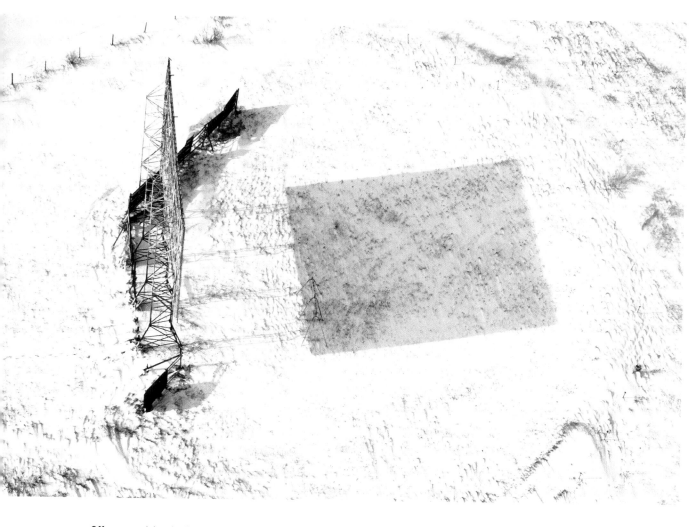

Off season drive-in theater and swing set in shadow Little Falls, NY, December 1989

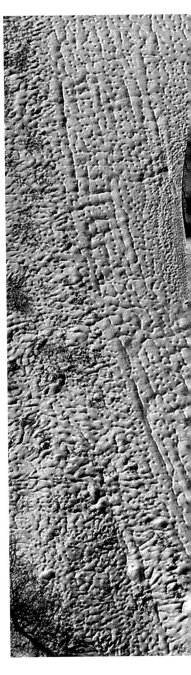

Winter backstop and baseball diamond Berkshires, MA, December 1985

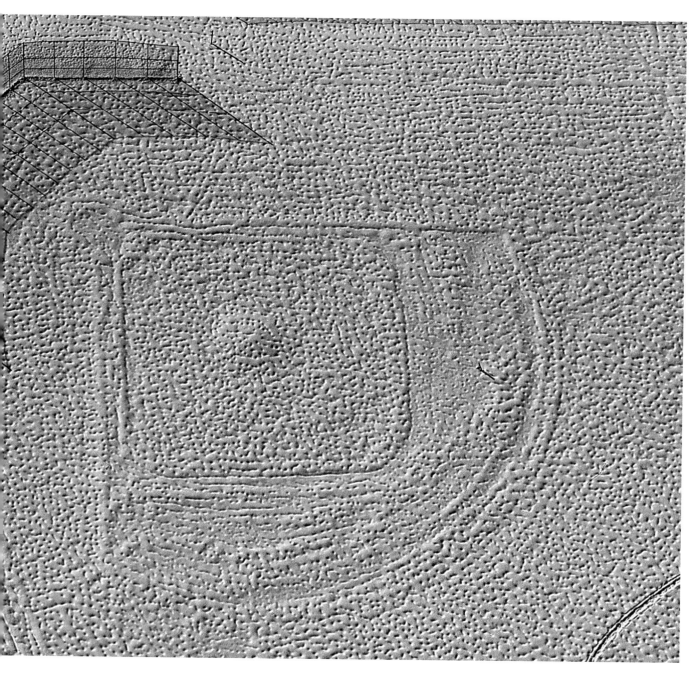

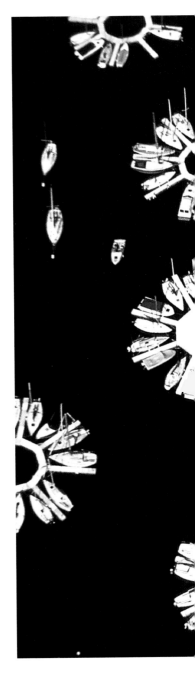

Daisy docks on Lake Michigan Chicago, IL, August 1990

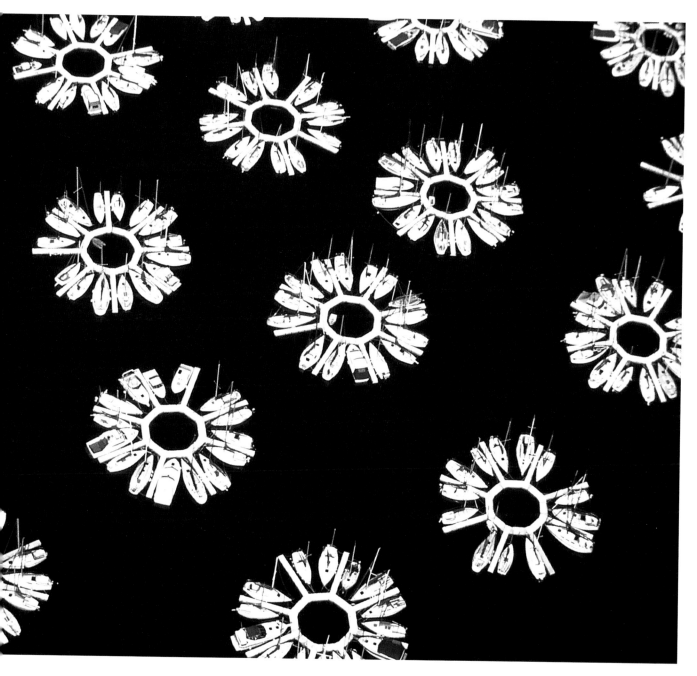

ACKNOWLEDGMENTS

The pictures in *The Playbook* were acquired over the past thirty years. Many of them were taken while I was in the air photographing for commissions and assignments to do with environmental and urban-planning issues. While these images were not part of the assignments, I am most grateful to the many people and institutions that have supported my aerial photography, giving me the opportunity to fly and photograph far afield: The National Endowment for the Arts, The Graham Foundation for the Advance Studies in the Fine Arts, Bill Stern and Rice Design Alliance in Houston, Texas, Dan Serda and Kansas City Design Center, Armando Carbonell and Lincoln Institute of Land Policy, Robert Davis and Seaside Institute and the Pienza Seaside Institute, Adele Chatfield-Taylor and The American Academy in Rome.

For their knowledge, creativity, and never-ending patience in getting this book into print, I want to thank Marianne Théry, Luce Pénot, Manon Lenoir, and Thames & Hudson.

My work is the result of collaboration with others who have influenced and informed my pictures. I would like to thank those I have worked with on book projects and exhibitions, including Anne Whiston Spirn of Massachusetts Institute of Technology, James Corner of the University of Pennsylvania, Julie Campoli of Terra Firma Design, François Hébel of the Rencontres d'Arles, Susan Yelavich, John Repps, Bill McKibben, Elizabeth Padjen, Richard Sexton, Elizabeth Werby, Lynda Hartigan, Roger Paine, Elizabeth Goodenough, Anne Foy, Odile Fillion, Pierre Nouvel, Dominique Carré, Rémi Babinet, Yancey Richardson, and Kathleen Ewing.

I have had important help from many people who have worked at Landslides on this project, including Drew Katz, Natalie MacLean, Robyn Nuzzolo, Laurie Ensley, Eric Greimann, Chris Brown, and Danielle McCarthy.

The spirit of this book was sparked by the very best of old and new friends who have engaged me in play, including Peter LaSalle, Richard Berne, James Wollf, and Skip Freeman. Above all, I would like to thank my family for their constant love and support: my brothers Paul, David, and James, my sister Alison, my in-laws, cousins, nieces, and nephews, my mother and father, my daughters Eliza and Avery, and especially my wife Kate who gives us the time to play.

On the cover: Twists and turns of waterslide park, Jersey Shore, NJ, July 19⁰

This edition first published in the United Kingdom in 2006 by
Thames & Hudson Ltd, 181A High Holborn, London WC1V 7QX

www.thamesandhudson.com

First published in 2006 in hardcover in the United States of America
by Thames & Hudson Inc., 500 Fifth Avenue, New York, New York 10110

thamesandhudsonusa.com

The Playbook was created by Editions Textuel, Paris
Original edition © 2006 Editions Textuel, Paris
All photographs © 2006 Alex S. MacLean (www.landslides.com)
This edition © 2006 Thames & Hudson Ltd, London

British Library Cataloguing-in-Publication Data
A catalogue record for this book is available from the British Library

Library of Congress Catalog Card Number 2006923081

ISBN-13: 978-0-500-51323-1
ISBN-10: 0-500-51323-6

Printed in Italy